DON'T TRUST THE LABEL
AN EXHIBITION
OF FAKES, IMITATIONS AND THE REAL THINGS

ARTS COUNCIL
1986–7

this catalogue is sponsored by ods plc

PREFACE

Don't Trust the Label is about ways by which we can be deceived or have our expectations disappointed during a visit to an art gallery or even if buying a picture. It is an exhibition about fakes and copies which have often misled experts, but also about how time takes its toll on works of art and how the restorer has sometimes further distorted the artist's intention. Above all, it is an exhibition encouraging us to look closely and to ask questions rather than always to accept what we are led to believe.

The exhibition has been devised and selected by David Phillips who lectures in museum and art gallery studies at the University of Manchester. His lively appetite for investigation has been fed by an amused and constructive scepticism, born of a career as a curator and how as a teacher of new curators. We are extremely grateful for his untiring efforts and for his perceptive observations which will do much to encourage our closer looking.

We add our thanks to those of David Phillips to the lenders, including major foreign museums, who have responded generously to the idea of a somewhat unconventional exhibition and to all those who have helped in its formation.

Finally we thank Associated British Foods plc and their Chairman Mr Garry Weston for their financial support of this catalogue.

JOANNA DREW
Director of Art

MICHAEL HARRISON
Assistant Director for Regional Exhibitions

ACKNOWLEDGMENTS

There have been a number of exhibitions of this type, in which 'right' and 'wrong' are placed side by side, since the **Vals of Echt** exhibition in the Stedelijk Museum in Amsterdam in 1952. The present exhibition has developed out of **Seeing is Deceiving**, at the Whitworth Art Gallery in 1984, which was organised by the Manchester University Art Gallery and Museum Studies Course. A number of the exhibits from that show are included here, and a lot of the research, as well as thought about the way in which it is presented, is due to the students who worked on the Whitworth exhibition.

I am especially grateful to the lenders for agreeing to quite a long tour. This poses problems for lending institutions but is perhaps even more of an inconvenience to private lenders. They have also all been to a lot of trouble in providing information and arranging for photography.

I have had a great deal of help from colleagues in Manchester, especially Ian Wolfenden, who teaches with me on the Art Gallery and Museum Studies Course, and Richard Thomson and Christa Grossinger who are also in the Department of History of Art. I have depended on many helpful conversations in the Whitworth Art Gallery with Francis Hawcroft, Sarah Hyde, Greg Smith, Linda Black and her predecessor in paper conservation Catherine Rickman. I have received similarly helpful suggestions and comments in Manchester City Art Gallery from Julian Treuherz, Brian Cardy, Ruth Shrigley and Maurice Davies.

Outside Manchester particularly time-consuming efforts were made for me by Kai Kin Yung in the National Portrait Gallery, Christopher Allan in the Hunterian Art Gallery, Philip Vainker in the Burrell Collection, Alastair Laing in the National Trust, Louise West and Ann Bukantas in the Ferens Art Gallery, John Sheeran and Giles Waterfield in Dulwich Art Gallery. I was also kindly advised by Dr. Marion Spencer, Anthony Griffiths, Christopher Wright and Professors Stephen Rees-Jones and Lee Johnson. Christie's and Sotheby's have forwarded a number of letters on my behalf.

It is a delight to select an exhibition with Michael Harrison in the Arts Council, who has contributed to the exhibition a great deal from his huge store of knowledge and contacts. Judith Kimmelman has kept us on the rails with patience and thoroughness.

Finally it should be remembered that such a wide-ranging exhibition depends upon the scholarly research of others. Many of the brief statements about the exhibits are based upon whole lifetimes of patient untangling of art historical mysteries. The scale of their research will be apparent to anyone who follows up the references in the footnotes.

DAVID PHILLIPS

SPECTRUM

This £8.1m painting is at the centre of a controversy. **Geraldine Norman**, Sale Room Correspondent, reports

Mantegna's 'Magi': fine art or forgery?

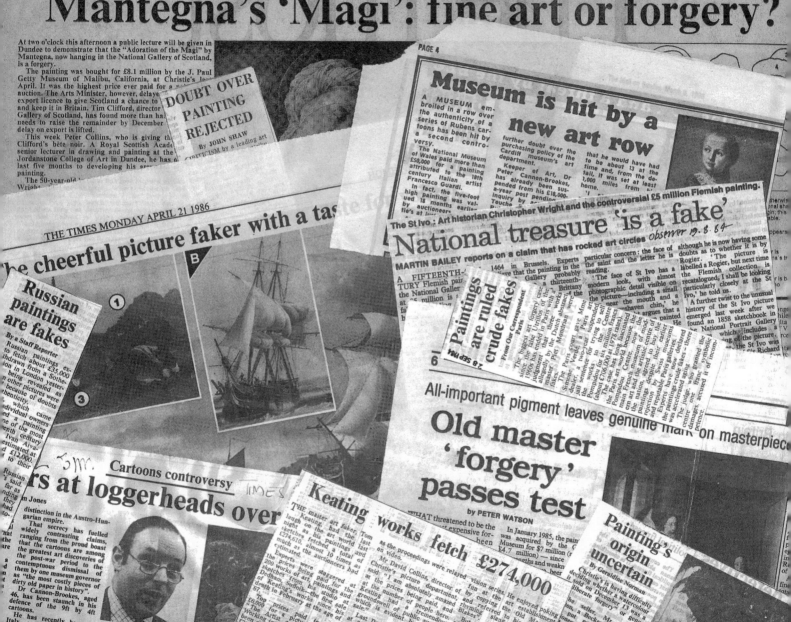

At two o'clock this afternoon a public lecture will be given in Dundee to demonstrate that the "Adoration of the Magi" by Mantegna, now hanging in the National Gallery of Scotland, is a forgery.

The painting was bought for £8.1 million by the J. Paul Getty Museum of Malibu, California, at Christie's in April. It was the highest price ever paid for a ___ at auction. The Arts Minister, however, delayed the export licence to give Scotland a chance to ___ and keep it in Britain. Tim Clifford, director ___ Gallery of Scotland, has found more than hal___ needs to raise the remainder by December ___ delay on export is lifted.

This week Peter Collins, who is giving th___ Clifford's bête noir. A Royal Scottish Acade___ senior lecturer in drawing and painting at the ___ Jordanstone College of Art in Dundee, he has ___ last five months to developing his arg___ painting.

The 50-year-old ___ Wright ___

DOUBT OVER PAINTING REJECTED
By JOHN SHAW
CRITICISM by a leading art

Museum is hit by a new art row

A MUSEUM embroiled in a row over the authenticity of a series of Rubens cartoons has been hit by a second controversy.

The National Museum of Wales paid more than £50,000 for a painting attributed to the 18th century Italian artist Francesco Guardi.

In fact, the five-foot high painting was valued 18 months earlier by auctioneers Touche ___ tie's at ___

further doubt over the purchasing policy of the Cardiff museum's art department.

Keeper of Art, Dr Peter Cannon-Brookes, has already been suspended from his £18,000-a-year post pending an inquiry by ___

that he would have had to be about 13 at the time and, from the detail, it was set at least 1,000 miles from ___ home. ___

The cheerful picture faker with a taste for ___
THE TIMES MONDAY APRIL 21 1986

National treasure 'is a fake'
observer 19.8.84

MARTIN BAILEY reports on a claim that has rocked art circles

A FIFTEENTH-CENTURY Flemish pain___ the National Galler___ at £5 million is ___ fa___ b___

1464 in Brussels. Experts believe that the painting in the Gallery probably ___ a thirteenth-century ___ Brittany with ___ work ___ the Dutch abstract___ master Piet Mondrian were ___

particular concern: the face of the saint and the letter he is reading.

'The face of St Ivo has a modern look, with almost photographic detail visible on the picture—including a small ___ near the mouth and a ___ shaven chin,' he argues that ___ ___ He ___

although he is now having some doubts as to whether it is by Rogier. 'The picture is labelled a Rogier, but next time the Flemish collection is recatalogued, I shall be looking particularly closely at the St Ivo,' he told us.

A further twist to the unusual history of the St Ivo picture emerged last week after we found an 1858 sketchbook in the National Portrait Gallery which includes a ___ ___ing of the picture. ___the St Ivo was ___ Richard ___

Russian paintings are fakes
By a Staff Reporter
Russian paintings expected to fetch about £35,000 ___ withdrawn from a Sothe___ ___ion in London yester___ ___ being revealed as ___ ___ in other pictures were ___ because of ___authenticity ___ which came ___individual owners ___ne of the most ___enth century ___ Ivan Aiva___ ___stimated at ___ ___d £12,000. ___to their

Russian ___ ___ said ___ far as ___ ___nding in ___they ___had to___

Paintings are ruled crude fakes
From Our Correspondent
Paris

The biggest art forgery case since ___ 1909 ___ has ended in Paris with ___ judgment that a ___ ___ally by ___ ___ ___ ___master ___ fakes. The Paris court ___ dealer ___ Simone Vend___ a two-year suspended jail sentence for trying to sell works to the Centre Pompidou for 35 million francs (about £706,000 at 1978 rates). The case has ___ main French museum, the Pompidou Centre ___cm art and the artistic centre ___ the paintings after ___ rejection, despite threats ___ was accelerated aging ___

22 SEP 1984
6

painted ___ modern ___ ___ museums ___ galleries ___ fakes—there ___ranted the ___ symbolic ___ ___accused of incom___ petent.

All-important pigment leaves genuine mark on masterpiece

Old master 'forgery' passes test
by PETER WATSON
WHAT threatened to be the ___ ___ expensive for___

In January 1985, the pain___ was acquired by the G___ Museum for $7 million (r___ £4.7 million) — since ___ ___nths and weakn___

Cartoons controversy
TIMES
___s at loggerheads over
___n Jones

distinction in the Austro-Hungarian empire.

That secrecy has fuelled widely contrasting claims, ranging from the proud boast that the cartoons are among the greatest art discoveries of the post-war period to the contemptuous dismissal of them by one museum governor as "the most costly pieces of dirty old paper in history".

Dr Cannon-Brookes, aged 46, has been staunch in his defence of the 9ft by 4ft cartoons.

He has recently been in Italy, consolidating his ___

Keating works fetch £274,000
THE master art faker, Tom Keating, had the last laugh on the art world last night ___ ___ his ___ sketches fetched a total of £274,210, almost 10 times as much as ___ estimated.

Experts were staggered as the prices being paid for the 200 works of art, paintings and sketches, from the studio at Dedham, Suffolk, the home of Keating's works since his death in February at the age of 63.

Top prices paid ___ £6,000 for a picture ___ Working on the site ___ been expected to ___ £200 and ___

as the proceedings were relayed on video.

Mr David Collins director of Christie's picture department, said: "I am absolutely amazed at the prices being paid, and ___ the number of people here. The Keating ground ___ had a tremendous groundswell of public support, which is evident by ___ sale.

At Last December ___ by tonight ___

Painting's origin uncertain
By Geraldine Norman
Christie's is having difficulty deciding whether it sold an ___ on 11 December a watercolour ___ liberate forgery or a genu___ ___on, a Beckenham ___ the seller, Mr ___ pur___ because ___ ___

INTRODUCTION

We very often start looking at a painting in a gallery with only a quick glance at the picture itself, followed by a careful look at the label. This may convince us that the picture concerned is, say, a Botticelli. Even in major art galleries, however, pictures very often do not quite live up to the promise of the label. Occasionally they may be forgeries. Much more often they fall short in one of a whole variety of less dramatic ways. Time or conservation treatments may have had such an effect that the artist who painted the pictures would hardly recognise them. They may turn out to be copies or replicas of other works, or may just be mis-attributed to the artist whose name is on the label. Prints are even more of a minefield. Many impressions of even the most famous prints were made when the original wooden block or metal plate had become worn by repeated printing. Often this was done without the approval of the artist. The impression before you may not have been made from the original block or plate at all, but from a copy plate made either by hand or photographically. It may not even be a picture which the artist ever imagined as a print, but may be a reproduction of a painting or drawing, translated by a copyist or by camera into one of the many different techniques of printing. Many old engravings, as well as modern colour reproductions, fall into this category. One way or another, that adds up to an awful lot of different ways of being misled, as we turn from the label back to the picture. The comparisons of pictures in this exhibition show what we may be missing. First of all though, it may be worth pausing to wonder whether it really matters much. If the picture is quite nice anyway, is it important if it is not accurately identified, or if another one is nicer?

It certainly matters financially, as we are reminded by a constant succession of scandals reported in the press. That often appears absurd. Why should a Constable which turns out not to be by John, but by his son Lionel, suddenly lose value? It may indeed be silly, but it is a silliness of the world of finance, not of the world of art. Works of art have become a form of currency and their value depends upon the credit in which they are held in the same way as the value of a

currency does. John Constables and U.S. dollars are very sought after currencies, Lionel Constables and Singapore dollars rather less so. If your five pound note turns out to have been forged rather than issued by the Bank of England it loses value in just the same way as does your Constable if it turns out not to have been issued by John. It does not have much more to do with the aesthetic qualities of your painting than it has to do with the sheer beauty of the fiver, forged or otherwise. Aesthetics and condition of painting matter to the market only because they mean that works of art have to be assayed, rather in the way that gold does. The uncertainties which always remain with art only add to its usefulness as a specifically speculative currency. Some academics, collectors and even dealers regret the hijack of art by finance, but hijacked it has been, and their opinions as a result are weighed in gold.

Authenticity and condition also matter to the historian. Unrecognised imitations or transformations bear false witness to their supposed age. A remarkable case in point is the famous picture of a mediaeval explorer discovering the edge of the world. It seems to have first appeared in a book of 1888 by the astronomer, Camille Flammarion, who pioneered the use of the most varied possible illustrations to enliven his oustandingly successful books of popular science. He would have needed no intention to deceive in making this illustration of a historical point in something like the style of a sixteenth century German woodcut. It has proved an irresistible image for later authors and picture editors, reproduced in over a hundred and fifty books, until recently almost always identified as an early print with no mention of its source.[2] It still appeared as such as late as 1965, in one of the most awesome achievements of scholarship of the century,[3] used for a discussion of Asian and European views of the cosmos. It is obviously a red-herring for any historian trying to understand sixteenth century ideas about the universe. It also confuses art historians. They might not have been deceived had not Flammarion's imitation been compounded in most of the reproductions by the omission of his obviously late nineteenth century border. This imitation and

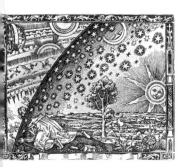

FLAMMARION *An Explorer discovering the World's Edge* 1888

transformation, like many of the other examples in this exhibition, muddle the accurate characterisation of schools of painting, or of individual artists. Such characterisation is an end in itself for some art historians, but it also provides the raw material for other historians who imaginatively use the evidence of art for historical, sociological, psychological or structuralist studies.

But does it all matter aesthetically? If you turn from the label back to the picture and it is not really what the label says it is, does that make it any less beautiful or interesting? It really does not, if your interest is just in whether a picture is immediately decorative or realistic. But if you want to see what really distinguishes the work of an artist, rather in the way that one might try to analyse a taste in order to find out the recipe, then there is a case for thinking that a misleading label can actually affect how a painting looks. It may trick you into overlooking qualities in it, or into seeing in it qualities remembered from other pictures, and so affect how similar works appear afterwards. The case rests on the idea that what you see in your mind's eye is not the picture in front of you, but a version of it processed by mind and eye, much transformed in the processing. In particular expectations of how it should appear, based upon the label, or on the assurances of an overenthusiastic curator, or even your own initial impressions, especially affect how it is seen.

The idea that we simply do not see what is actually in front of us is familiar to anyone who has looked through the illusions in any work on visual perception.[4] The diagram here is a reminder of how expectation can change how a picture looks. It seems to be just an abstract pattern, but now look at the illustration of catalogue no. 25a. The diagram turns out to conceal a representation. Oddly, it actually looks different, even though it has not changed at all. All that has changed is your expectation about it. Demonstration that prior knowledge and expectation are involved in recognising what a picture represents is by no means proof that they may be similarly involved in finding the representation beautiful. I can only plead personal

experience for believing that they do work in aesthetics in something like the same way.

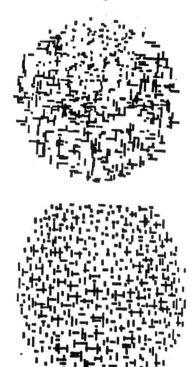

As an example look at two pictures prepared in the U.S.A. in 1966 by A. M. Noll of the Bell Telephone Laboratories.[5] The idea was to compare reactions to a reproduction of a painting by Mondrian,[6] and to a computer generated pattern, with some of the same characteristics, but randomly distributed. The one hundred subjects to whom the pair were shown did not prove too good at spotting which was the Mondrian, and a majority thought the computer generated pattern preferable as a picture in any case. All the subjects were Bell employees, with no special reason for knowing much about Mondrian, and the results might have been different with a group of people familiar with his painting. There is a spotty,

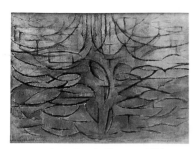

MONDRIAN *Apple Tree in Blossom* c 1911
Gemeentemuseum, The Hague
© DACS 1986

left
Patterns, generated by a computer (*top*) and
derived from a painting by Mondrian of 1917
(*bottom*)

clumped quality about the computer pattern, which is quite unlike anything by Mondrian. He moved only gradually towards the abstraction of paintings like the one reproduced, through a period of years in which the objects in his pictures, though recognisable, were simplified into ever more regular patterns. As the eye travels across his paintings they have a periodic quality, like the beat in music. The computer pattern was designed to be more random, and does not have this periodic quality. The evenly spaced bars of the Mondrian are also graded in size, so that the pattern thins out in places, like soft shading. I find the effect rather beautiful, but suspect I am seeing in it echoes of remembered Mondrian. It would be only too easy to see the same qualities in a computer generated pattern which more closely imitated the distribution of bars in the Mondrian. The imitation might be convincing at the time, but would be likely to have characteristics of its own which could confuse later perceptions of his pictures.

That suggests that it is impossible to see what makes the work of an artist or school special without seeing a lot of it. Certainly very unfamiliar work, whether old or disconcertingly modern, is often hard to get the hang of unless it has immediately decorative effects of colour or pattern, or is spectacularly realistic. Getting to know a difficult artist like Mondrian is a bit like poring over a chunk of text written in a difficult handwriting, or an imperfectly understood language. At first such texts seem impenetrably meaningless, but here and there as the eye moves around them possible meanings appear. Some of these never connect up with anything else and are abandoned, but others do link up, and suddenly the point of a whole section jumps into focus. The interesting thing about this kind of puzzling out is that it is a process in which at each moment what has so far been worked out is fed back into the next attempt, so that whole chunks of meaning at a time fall into place. Once again it is a big jump to go from believing that feeding back knowledge is involved like this in working out simple meaning, to assuming that it works in something like the same way in the development of our responses to beauty in art, but they seem to me to work like that.

In art, however, the visual beauty or interest which begins to seem characteristic of a particular painter is never the end of the story. Works of art are like unfathomable murder mysteries, in which as fast as the puzzle seems solved, there turns out to be more to the solution than meets the eye. In this process a work forged, or mis-attributed or damaged so as to transform it is a false clue.

If attributions do matter, but labels and other confident assurances are not to be trusted, what criteria can be relied on? There are three approaches. One is simply to look at a great deal of an artist's work, and then to trust your judgment of whether a newly encountered work looks like the same kind of thing. The other two criteria depend on finding evidence about the work that has nothing to do with its effect as a work of art, which means looking for scientific and historical information about it.

Stylistic judgment is the slipperiest approach, but remains the basis on which the whistle is most commonly blown in the first place, especially in forgery scandals. In the case of Keating's Palmer fakes, for instance, two painters who had based some of their work on Palmers, Paul Drury and Graham Sutherland, and one leading Palmer scholar, were confident enough that the pictures were wrong to put their names to letters in the press condemning them long before the consensus of opinion had finally turned against them.[7] At the time, as often happens, such opinions only served to intensify the controversy. The trouble is that it is extremely difficult to put visual experience into words, so that statements about the qualities which distinguish one work from another tend to be vague. Almost everyone is familiar with the kind of judgment involved at one level, from recognising by the handwriting on an envelope from whom a letter has come. Try to describe the familiar handwriting, and the description will usually apply to the writing of dozens of people, none of which would be confused with the familiar hand for more than a moment. A line drawing may just consist of marks rather like those of handwriting, but generally a painting has many more characteristics, which hopefully also add up to an effect

of beauty which handwriting does not usually have. The problem of description is the same, and instead the art expert relies on a shock of recognition which is rather like the shock of recognition of hand-writing. It depends on the existence of a body of work which, on stylistic and other grounds, is agreed by most critics to be authentic, and much of the effort of art history goes into building up such a body of work for each identified painter.

This shock of recognition can be turned against anyone who is not really intimately familiar with an artist's work, by skilful copying or restoration, or by the common forger's tactic of composing a picture based upon details from a number of authentic works. The trick depends on the viewer wanting the picture to turn out to be authentic. The details in that case do not even seem to need to be very well imitated for a very deceptive effect to be created, which depends upon the visual confidence trick of arousing expectations with one detail, which others then seem to fulfil. Even when the authentic sources of a number of such details in a forgery have been recognised suspicions are not always aroused, since many artists do play musical chairs with elements in their own work in rather the same way. Tom Keating's Palmers were usually done like this.[8]

With all these uncertainties, it is not surprising that questions of attribution are rarely solved by stylistic arguments alone. The usual pattern is that controversies raised on stylistic grounds only end in a consensus of opinion on the basis of evidence about non-aesthetic aspects of a picture. These are sometimes historical. There is often argument about whether whatever a picture represents looks right for the supposed period. This approach almost always raises more problems than it solves. There is currently debate over a fortification in a mural in Siena.[9] Is it of a type not built before the age of gunpowder, proving that that painting is at least a hundred and fifty years later than thought, and not by the early master Simone Martini? The fortification experts differ, and it turns out that we simply do not know enough about fortification to settle the issue. Costume details have

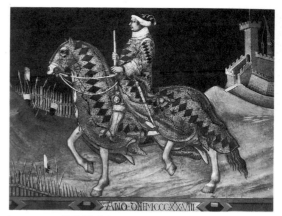

SIMONE MARTINI (?) *Guidoriccio da Fogliano*
Palazzo della Signoria, Siena

proved notoriously unreliable as evidence for the same reason. A more useful kind of historical evidence is the record of ownership and display of the painting itself. In many cases it is possible to reconstruct it, from labels, auctioneers' numbers and customs stamps on the backs of pictures. If the inscriptions can be correlated with references in wills and inventories, sale and exhibition catalogues, paintings can occasionally be traced all the way back to the easel, or to an owner personally acquainted with the artist. Provenances like this often occupy a substantial part of museum exhibition catalogues.

Historical evidence is not without its dangers. Even if there are no gaps in the record, the old lists are often vague about details of size, or whether a painting is on canvas or wood. With so many versions of many paintings, and with so many old mis-attributed pictures of most popular subjects as well, it is often not possible to be sure that the listed picture is really the very one now being researched. Provenances can also be deliberately falsified.

In difficult cases scientific evidence is often the deciding factor, in identifying part of a picture as restorer's overpaint, or the whole thing as forgery. This was the case over Wacker's Van Goghs,[10] van Meegeren's Vermeers[11] and Keating's Palmers,[12] all of which still had their champions until the results returned from

PALMER *The Shearers* 1833–4
Private Collection

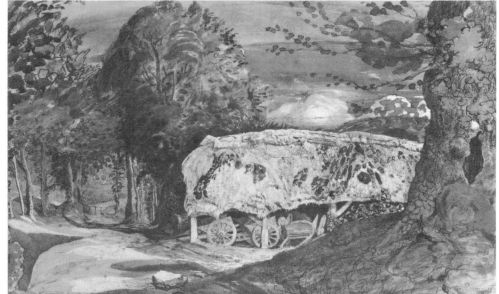

12a

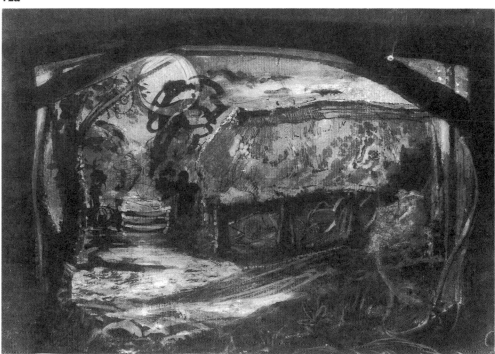

12b

This picture by Keating combines the general
features of **12a** with the foreground details
of The Shearers (see catalogue entry)

Details of the paper and the corner of the plate mark from two modern reproductions of prints. *Above* showing horizontal 'laid' lines appropriate for an imitation of an old paper (**22c**). *Below* showing an inappropriately modern 'wove' texture (**23a**). See catalogue entry **23**.

Labels on the backboard of a Turner watercolour
Whitworth Art Gallery, Manchester

the laboratory. The idea is to try to find some component of the work of art which can be convincingly shown to be of an inappropriate date. In simple cases this is often just a matter of spotting obviously modern paper or canvas, like the modern paper in the Rembrandt reproduction in this exhibition (cat. 23a). An old painting which shows no signs of age, such as fading, or splitting of panels, cracked paint and old restorations is suspicious too. If suspicion is all there is, more sophisticated analysis can be applied, especially to pigment. All inks and paints just consist of little coloured grains embedded in a film of oil or gum, or some other fairly transparent substance which sticks to paper or canvas and hardens. The materials used at different times, and the ways in which they were produced for sale to artists have been quite thoroughly researched. Sometimes just a view of the size and shape of the grains down a microscope is

enough to make a case that they were made by a modern industrial process as was the case with the Botticelli *Madonna of the Veil* (cat. 2b), but a great many more elegant but standard means of chemical analysis may also be brought to bear, to detect substances whose synthesis is believed to have been beyond the chemical knowledge of the supposed age of the work.[13]

Even where only the most authentic materials have been used, inspection with x-ray, infra-red[14] or ultra-violet radiation will often reveal that they have been used in ways unusual for the artist. All these radiations are disturbances of the same kind as those we see as light, but on different scales. Like light, when they meet substances they are either reflected, absorbed, or just pass on through, but which of these reactions happens with any individual substance depends on the

Details of **1a** in normal light (*top*) and ultra-violet light (*bottom*). Restorer's overpaint, for instance either side of the nose, appears very dark in the UV picture.

scale of the radiation, and so varies from one of these types to another. Only light is absorbed by the detectors in the eye, so that the other radiations are invisible, but chemicals in photographic detectors do absorb them, and can be used to record images. Wood reflects or absorbs all visible light, but is partially transparent to some x-rays, so that the fabrication of a panel may be revealed beneath the paint (see cat. 1b). Metal nails and paint or filler containing lead white are not transparent to x-rays and so show up well. New paint absorbs ultra-violet radiation, but older paint reflects some of it back, changing it into visible light in the process in a complicated but helpful way, so that even an inspection by eye with an ultra-violet lamp will often show up recent restorer's overpaint. (see cat. 1a).

Modern restoration, or modern paintings mis-dated in good faith, are usually detected by such tests, but the forger or dishonest restorer can anticipate them all. In practice it is rarely necessary. The tests are time-consuming and expensive, and cannot possibly be applied except in a handful of cases. What the forger needs to do is just to anticipate the most usual tests, so that suspicions are not aroused. Van Meegeren was the shrewdest exponent of this policy.[15] He used real old canvases, from which he had scraped most of the seventeenth century paint. This not only avoided the questions which a modern canvas would have raised, but also helped the forged paint to develop cracks like those of old paint, since the cracking of the thin remaining layer of seventeenth century paint formed a basis for craquelure in Van Meegeren's paint, with the encouragement of various procedures. Even so, Van Meegeren knew that his paint was likely to be subjected to preliminary chemical testing. Restorers examining a picture will often make small trials to find solvents which will dissolve the varnish and overpaint without affecting original paint. This is less alarming than it sounds since paint of the seventeenth century and earlier is commonly very hard and insoluble indeed. This poses a major problem for the forger, since easily soluble modern paint would instantly arouse suspicions. Van Meegeren's way round the problem was to use a medium which was only partly

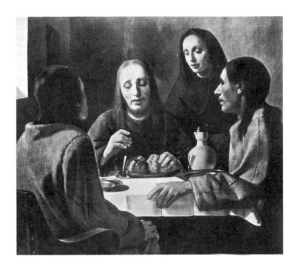

A NEW VERMEER BY ABRAHAM BREDIUS

IT is a wonderful moment in the life of a lover of art when he finds himself suddenly confronted with a hitherto unknown painting by a great master, untouched, on the original canvas, and without any restoration, just as it left the painter's studio! And what a picture! Neither the beautiful signature "I. V. Meer" (I.V.M. in monogram) nor the *pointillé* on the bread which Christ is blessing, is necessary to convince us that we have here a—I am inclined to say—*the* masterpiece of Johannes Vermeer of Delft, and, moreover, one of his largest works (1.29 m. by 1.17 m.), quite different from all his other paintings and yet every inch a Vermeer. The subject is *Christ and the Disciples at Emmaus* and the colours are magnificent—and characteristic : Christ in a splendid blue ; the disciple on the left, whose face is barely visible, in a fine grey ; the other disciple on the left in yellow—the yellow of the famous Vermeer at Dresden, but subdued so that it remains in perfect harmony with the other colours. The servant is clad in dark brown and dark grey ; her expression is wonderful. Expression, indeed, is the most marvellous quality of this unique picture. Outstanding is the head of Christ, serene and sad, as He thinks of all the suffering which He, the Son of God, had to pass through in His life on earth, yet full of goodness. There is something in this head which reminds me

of the well-known study in the Brera Gallery at Milan, formerly held to be a sketch by Leonardo for the Christ of the *Last Supper*. Jesus is just about to break the bread at that moment when, as related in the New Testament, the eyes of the Disciples were opened and they recognized Christ risen from the dead and seated before them. The Disciple on the smaller shows his silent adoration, mingled with astonishment, as he stares at Christ.

In no other picture by the great Master of Delft do we find such sentiment, such a profound understanding of the Bible story—a sentiment so nobly human expressed through the medium of the highest art.

As to the period in which Vermeer painted this masterpiece, I believe it belongs to his earlier phase —about the same time (perhaps a little later) as the well-known *Christ in the House of Martha and Mary* at Edinburgh (formerly in the Coats collection). He had given up painting large compositions because they were difficult to sell, and painters like Dou and Mieris were already getting big prices for their smaller works.

The reproduction [PLATE] can only give a very inadequate idea of the splendid luminous effect of the rare combination of colours of this magnificent painting by one of the greatest artists of the Dutch school.

VAN MEEGEREN *The Supper at Emmaus*
Museum Boymans-van Beuningen, Rotterdam

The scholar Bredius's enthusiastic article accepting *The Supper at Emmaus* as a masterpiece by Vermeer.

oil, and was mostly a modern synthetic resin related to Bakelite, which could be painted on wet just like oil paint. Dried with heat, it developed craquelure, whilst becoming extremely hard and insoluble. Subjected to further chemical analysis it would have been immediately detected as modern, but the important point was that because it gave just the expected result in preliminary tests, it was not suspected. On the contrary, it set up just the confident expectations

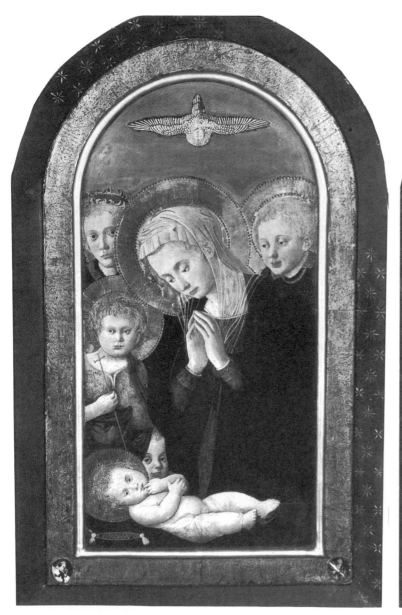
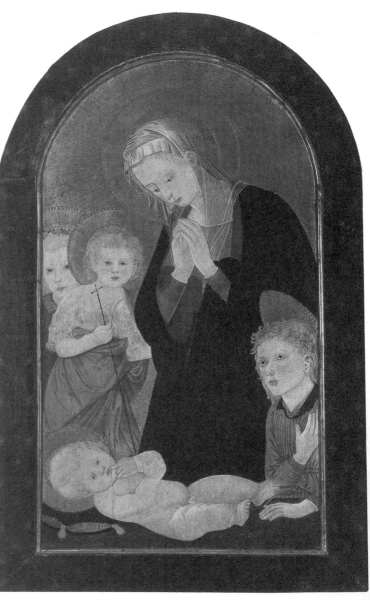

which allowed very knowledgeable art historians to see in the paintings artistic qualities which in retrospect seem incredible.

The stylistic, historical and scientific judgments on which attribution depends can therefore all be turned around and used to bolster confidence in a painting put forward under a false label. The only defence for those in the business of doing the attribution is to weigh all the evidence before making a commitment — and then to weigh all the evidence about the credibility of the evidence. Few imitations will stand up to this for long. It is rarely economically worthwhile for the forger, dishonest restorer or over-enthusiastic dealer to anticipate more than initial historic or scientific tests, or to become more than passably proficient as a mimic. This is the expert's chance. Unfortunately the opportunities of the art market will not usually leave time for all the research, and this will remain the crack through which all kinds of imitation and mis-attribution will continue to slip.

Two pastiches – *far left* **2a** *left* an example from the Metropolitan Museum of Art, New York (41.100.9) – from the large number associated with the Pseudo Pier Francesco Fiorentino based upon Fra Filippo Lippi's *Adoration* in the Uffizi, Florence (below)

The fact that artistic imitations can and should be detected does not mean that they do not have qualities of their own. Their authors could not rival the invention and imagination which are the achievement of great original artists, but their efforts can be allowed the status of performances, a bit like the performances of plays or music. Faithful reproductions or copies are much more enjoyable achievements than poor ones. Pastiches, whether done in good faith like those by the mysterious Pseudo Pier Francesco Fiorentino (cat. 2a), or to deceive like those of the equally mysterious Spanish Forger (cat. 3), are like performances too, but by rather eccentric performers, whose work has idiosyncracies of its own which are interesting once they are recognised. No wonder that the work of forgers is now not only collected, but forged in its turn.

However good the imitation or reproduction, it is not the same as the 'real thing'. You may be convinced that a mistaken label can prevent you from seeing the difference. It still is not easy to ignore the label, because it is so tempting to be reassured that what

we are looking at is the 'real thing'. We may feel that we are far too rational for that to be important, but it is really quite possible that the mind does at the very least find it much easier to respond to beauty in a work of art if the viewer is convinced that the work is an actual authentic relic of the handywork of a known artist, or at least of a known period. We actually have very little idea about what mental processes are involved in aesthetics. Maybe aesthetic processes are related to those other common occupations of the human mind, religious belief, and worship of relics, both of which require total conviction of the authenticity of the object of veneration. These mental occupations are quite mysterious, and although it might seem alarming to put artistic response in the same category, there are suspiciously many parallels between religion and aesthetics. Only the market for holy relics has provided even more scope for the forger than the art market. Maybe belief is a helpful first step in the aesthetic process, and one of the functions of an art gallery, with its pompous architecture and confident little labels, is to convince you that all is well as far as authenticity goes, so that you can safely launch into the next stage of getting worked up into a fine artistic rapture. This is a crutch which you should throw away. It is surely what happens next, the part of the process which does not depend on belief, which is most interesting for the study of art. The label should therefore not be mistrusted only because it is so often wrong, but also because trusting it in the first place may so fill the mind with awe as to paralyse critical faculties rather than awaken them.

DAVID PHILLIPS

1a FOURTEENTH CENTURY ITALIAN SCHOOL
Madonna and Child with Saints
tempera on panel
43.2 × 43.9 (open)

• Astley Cheetham Art Gallery,
Stalybridge, Tameside Metropolitan
Borough Council

1b Attributed to ICILIO JONI 1866 – after
1936
**Triptych in the manner of the
circle of Matteo di Giovanni**
oil on panel, 55.7 × 50 (open)

• University of London, Courtauld
Institute Department of Technology

Two portable triptychs – altarpieces of
three panels – one made in the
fourteenth century but much
transformed by restoration, the other
an early twentieth century forgery.

The first label not to trust is the one
on the plinth of 1a. Nobody now thinks
this triptych is by Buffalmaco, but by an
unknown artist, about a hundred years
later, towards the end of the
fourteenth century. Only the painted
panels are of this date. The gilded
framing and heavy plinth are modern.
The original paint is also rubbed and
overpainted in places. The face of the
child has been especially transformed. In
a photograph in ultra-violet light, the
modern overpaint appears very dark
(see illustrations p11). The emphasised
shadows making the lower part of the
nose prominent are uncharacteristic of
fourteenth century painting. They
resemble the dark touches of shadow
on faces in nineteenth and twentieth
century watercolours in which features
are suggested by the shadows around
them, without their outlines being
complete. This is rather how we see
things in the play of light, but not how
things were represented in painting at
this early period. Compare the firmly

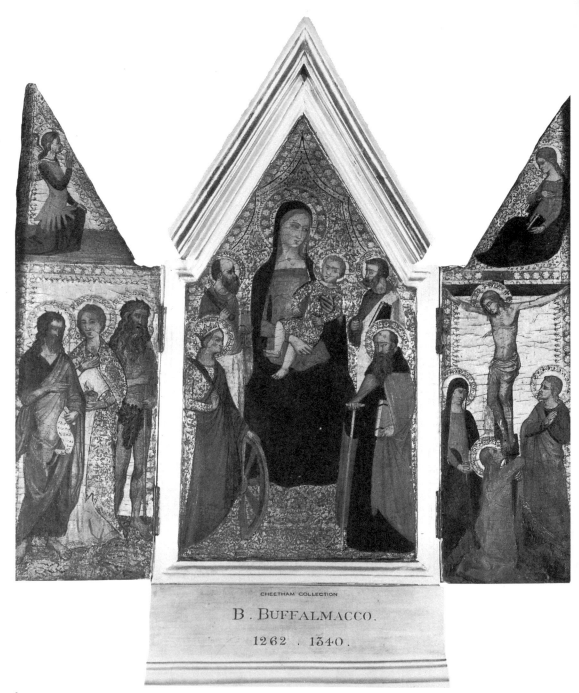

CHEETHAM COLLECTION
B . BUFFALMACCO.
1262 . 1340.

1a

outlined authentic nose of the right hand saint in the left hand wing.

Altarpieces of this kind, but in different styles of painting, continued to be made for over a century after the date of 1a, and 1b is a forgery of one in the manner of Matteo di Giovanni, who was working in Siena in the later fifteenth century. With its harsh shadows and outlines, the forgery was probably not intended to be attributed to Matteo himself, but to an unknown artist of the period working in the style which he briefly made fashionable. It was made before x-rays became a standard means of inspection and is instantly exposed by them. The panel is seen to be damaged by wormholes which have been filled before the picture was painted. No proud artist of the period would have contemplated setting to work on a worm-eaten panel. Nor, even more conclusively, would he have attached the carving to the edge of the panel with the modern nails seen in the x-ray, made by automatic cutting and shaping of evenly drawn wire, quite unlike the beaten nails of the time. The nail heads are buried beneath undisturbed preparation and gilding, so the picture cannot pre-date them.

A traditional attribution to the forger Joni, working in Italy in the first half of this century, is supported by recent research into the decoration impressed into the gilding. A scholar[16] has identified the impressions of particular stamps in different paintings, both forged and genuine, rather as the characteristic impressions of worn typewriters are identified by forensic science. 'The' eight point stamp used on the Virgin's halo and on the border above it was also used on a panel in the Ashmolean Museum, now known from pigment analysis to be modern, and on other works associated with this forger.

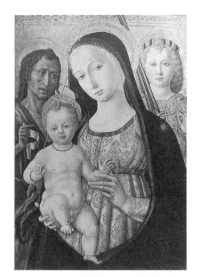

MATTEO DI GIOVANNI *Madonna and Child with SS John the Baptist and Michael the Archangel*
The Barber Institute of Fine Art, University of Birmingham

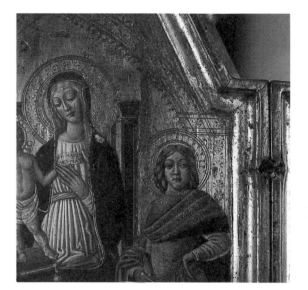

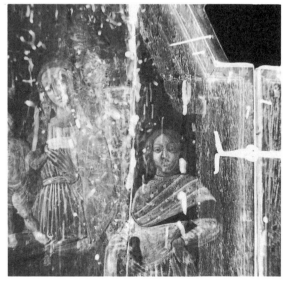

Photograph in normal light (*top*) and x-ray (*bottom*) of a detail from **1b.**

2a THE PSEUDO PIER FRANCESCO
FIORENTINO 15th Century
**Madonna and Child with Saints
and Angels**
tempera on panel, 76.25 × 38

- Astley Cheetham Art Gallery
Stalybridge, Tameside Metropolitan
Borough Council

2b IMITATOR OF SANDRO BOTTICELLI
1444–1510
The Madonna of the Veil
oil on panel, 88.2 (max) × 45.8

- University of London,
Courtauld Institute, Department
of Technology

Two panels, supposedly both for the
market for domestic scale images of the
Madonna in fifteenth century Florence,
one genuinely of its period, but a
plagiarism, the other exposed on
scientific grounds as a modern forgery.

There are no doubts that 2a is a
fifteenth century panel, except for the
clumsy blue sky, which is modern
overpaint, and other patches of
overpaint, especially on the faces and
hands of the figures. However, though
not a forgery, this painting is very much
a pastiche of another painter's
invention. It is one of many rather
similar pictures, all recombinations in
various permutations of figures copied
from a famous work by a major master
of the time, Fra Filippo Lippi.[17] In the
absence at the time of any law of
copyright, there is no reason for
thinking these pastiches were not
produced and sold openly. By whom
nobody knows. It may have been one
artist or a workshop, or several. As in
similar cases, art historians have
invented what they charmingly call a
portmanteau artist, to whom all
pictures of the type are conveniently
given. The ghostly Pseudo Pier
Francesco is named after a real Pier

Francesco, who painted rather similar,
but more originally imaginative
Madonnas for the same demand.

The great Botticelli and his studio also
produced a large number of panels for
this market towards the end of the
century. But not 2b. It was probably
painted not long before Lord Lee
bought it, for $25,000, in 1929.
Although it had no earlier history, it
was accepted at the time as a
masterpiece, at least by Roger Fry,
who in a letter to Lord Lee[18] kindly
mentioned the enthusiastic support for
the painting and interest in publishing it
of his young friend Kenneth Clark. It
was reproduced by the Medici Society.

When the panel came into the
possession of the Courtauld Institute
after the 2nd World War, it was
quickly identified as a forgery. The
grains of pigment in the Madonna's blue
robe, even under a hand-held lens,
were seen to be too finely ground for a
paint made before the nineteenth
century, and later chemical tests
showed that brown paint in the foliage
is not, as in authentic works of the
period, green copper resinate pigment
which has gone brown with age, but an
umber pigment imitating this well
known discolouration.[19] The wooden
panel is also quite unlike the high quality
timber on which an artist of such status
usually worked.

Some of the details of the picture are
inventions, but most were copied from
different originals, especially the
Madonna and Child[20] and the arch
above them.[21] The vacant and
apparently sedated appearance of
mother and child are very unusual for
Botticelli, a fascinated observer of
human mood who endlessly explored
facial expression appropriate to the
glances and touches exchanged by the
figures in his pictures. Dreamy, self-

absorbed figures, like the famous
Venus, are always accompanied by
animated companions. The head of the
child which seems so abstracted in the
forgery, for instance is transformed in
the original *St Barnabas Altarpiece* just
because the child is at a different angle,
leaning forward rather than lying back,
and reaching out towards the attendant
figures in a touchingly convincing way. In
Botticelli's pictures of Madonnas alone
with their children, the two are always
intensely aware of one another. Who
painted this forgery is not known,
though similar Botticelli panels were on
the market in the nineteen fifties. The
rather fish-like mouths of the figures
perhaps find a faint echo in the equally
fishlike mouths seen in profile in the
Melozzo da Forli forgery in the National
Gallery,[22] which also has an elaborately
bumpy surface rather like the one on
this panel.

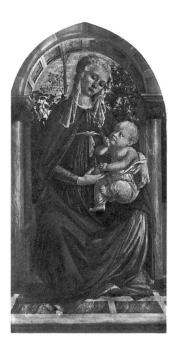

left
BOTTICELLI *The Madonna of the Rosebush*
Uffizi, Florence

far right
A detail from BOTTICELLI's *Saint Barnabas*
altarpiece Uffizi, Florence

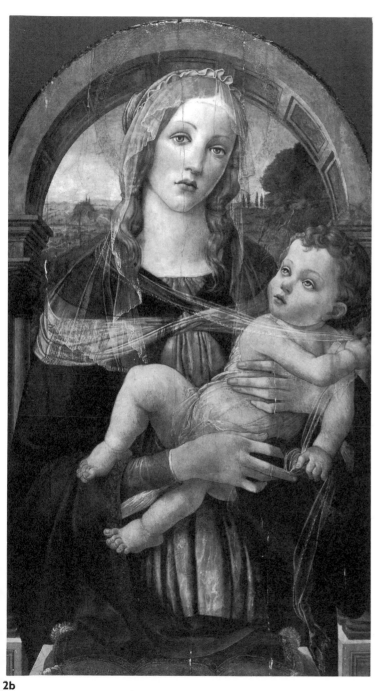

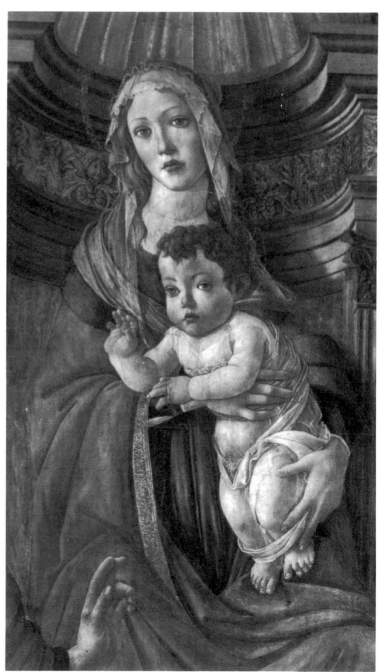

2b

3 THE SPANISH FORGER active? 1890–1930

The Betrothal

tempera on oak panel octagonal, 11.3 × 11.3

• Abbot Hall Art Gallery, Kendal, Cumbria

A panel identified as one of a huge group of forgeries, on historical and stylistic evidence.

The Spanish Forger is perhaps the most intriguing and successful forger whose work has so far been spotted. Over a hundred and fifty works are now attributed to him – or her, or, perhaps them if they were a workshop. Nobody knows who made them. They all seem to have been first acquired, with no previous history, in the first thirty years of this century in France, which suggests a country for the forger, and a period of production. The confusing 'Spanish' association comes from a panel, subsequently shown to be one of the forgeries, which art historians of the twenties attributed to the Spanish master Jorge Ingles. In fact most of the forger's output imitates the style of French painters of the fifteenth century, and the success of the operation depended upon the modesty of the works forged. There was no attempt to produce work by named artists, just modest but still eminently collectable panels and leaves by the many obscure painters of such things. Often, the forger simply illuminated genuine, but previously un-illustrated manuscripts. A few works in the forger's style had been spotted for what they are by 1914, but the patient work of identifying the rest has been done especially by generations of librarians in the Pierpont Morgan Library in New York.[23]

This picture is rather odd in that it is hard to see for what part of the art

market of the fifteenth century such a tiny panel would have been done. The forger used versions of the same scene in several larger panels, and in a manuscript. The figures derive from wood engraved copies of authentic manuscripts in two popular works about the middle ages, published in France in the later nineteenth century. Almost all the forger's figures can be

traced back to these sources or others like them, and such a correspondence, and a history of ownership going back no further then early twentieth century France, is now a sure sign of a likely attribution to the forger.

His, or her, or their rather dreamy style is itself a minor artistic achievement. The impassive figures,

each lost in a pensive world of their own, have perhaps been hypnotised by the monotonously emphasised patterning of their own draperies.

Scientific tests on a manuscript in the Pierpont Morgan Library have confirmed the presence of recent pigments.

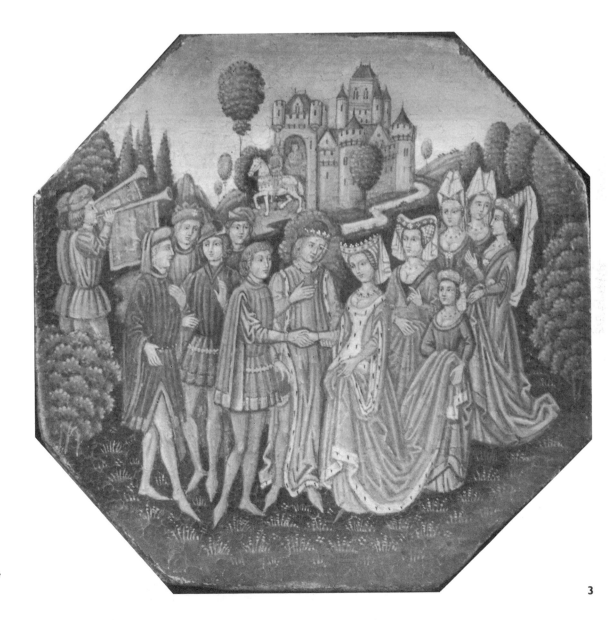

3

4 Imitator of PIETER BRUEGHEL THE
YOUNGER 1564 – 1637/8
A Village Procession
oil on panel, 28 × 44.3

- University of London, Courtauld
Institute Department of Technology

A modern forgery of a seventeenth
century copy, exposed by technical
examination.

The Brueghels were a whole dynasty of
painters spanning the last decades of
the sixteenth century and the early
ones of the seventeenth including three
generations of Pieters, three Jans and
an Ambrosius. Pieter Brueghel the
Younger concentrated on imitating the
manner of his famous father, Pieter the
Elder. This little scene appears in the
top right hand corner of a painting in
the Fitzwilliam museum,[24] thought to be
by Pieter the Younger and based on a
lost composition by his father. There
are several other versions from the
seventeenth century, just of this little
detail, so the discreet appearance of

this little addition to the group would
have caused no raised eyebrows.

It is exposed as a forgery by the
craquelure of the paint, especially on
the wall of the house just to the right
of the processional saint. Though
convincingly like the patterning of dirt-
filled cracks in paint on panels of this
period, these are not real cracks at all,
but lines painted finely on the surface of
the paint. Further analysis detected the
presence of the post 1860's pigment
chromic oxide in the walls of the
house.[25]

PIETER BRUEGHEL THE YOUNGER
Kermesse with Theatre and Procession
Fitzwilliam Museum, Cambridge
above whole picture, *below* detail

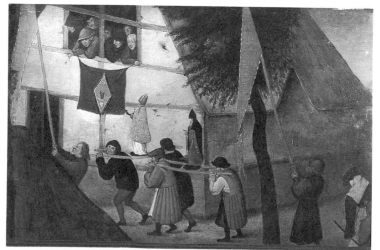

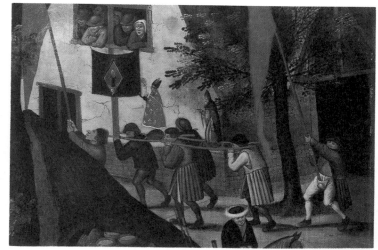

5a after DIRCK VAN BABUREN 1590 – 1624
The Procuress
oil on canvas, 100 × 96

- Rijksmuseum, Amsterdam (on loan from the City of Amsterdam)

5b HANS VAN MEEGEREN 1889 – 1947
'after Dirck van Baburen
The Procuress c. 1940
oil (?) on canvas, 98 × 103.

- University of London, Courtauld Institute Galleries

Two versions of a famous seventeenth century painting, one a copy of the period, the other a mid twentieth century forgery, which demonstrate the contrasts between traditional and contemporary use of oil paint.

Baburen's original painting is about light. Notice in the fine copy, 5a, how the light comes through the fingers of the girl touching the strings as from a lantern, whilst in contrast the wrinkled outstretched palm of the procuress is angled so as to give the maximum play of shadow. The whole picture is made up of carefully modelled textures and effects of this kind.

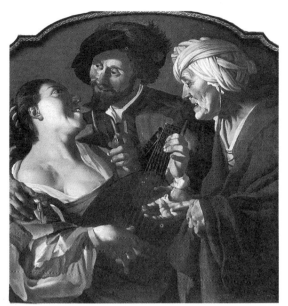

5a

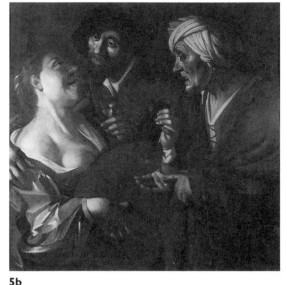

5b

They hardly work at all in 5b because the forger has made no attempt to build his paint surface up in the layered manner of oil painters before the nineteenth century. The painter of 5a would probably first have modelled the light and shade of the faces in nearly monochrome brown, and then added semi-transparent layers of colour over the modelling to obtain both subtle complexion tints and soft shading. In contrast the forger has simply mixed on his palette the colour he wanted to end up with and painted it straight on, adding the highlights last in crude thick touches. Though 5a is only a copy it has great delicacy of colour and modelling which is absent from the shiny and rubbery faces in the forgery.

The composition appears in the background of two paintings by Vermeer,[26] but Baburen's original painting was all but unknown, until it came on the market in 1949 from a collection in the Isle of Wight. In its absence until then, one can imagine the temptation for van Meegeren to supply the missing masterpiece, which every art historian knew from Vermeer's paintings might well still exist. Just where the forgery fits into his career is a mystery. It is not listed amongst his works in the publication of the official inquiry into his forgeries.[27] It was said in 1960 to have been on the market until 1950,[28] but the confidential circumstances in which it came into the possession of the donor to the lenders in the confusion of immediately post-war Holland are shrouded in agreeable mystery.

It certainly has the characteristics of van Meegeren's later forgeries. The canvas is an old one from which a seventeenth or eighteenth century painting has been scrubbed. Traces of the original picture remain at the very edges, where an analysis of paint layers revealed not only van Meegeren's ochre paint under grimy varnish, but below that a thin layer of old red paint, glazed in the traditional manner on a thicker layer of red earth, on an old preparation.[29] Van Meegeren's colours by this time were all dark and dirty, crudely imitating the effect of dirty old pictures, but quite without the rich variation of tone even in the copy here. By this stage van Meegeren was no longer even bothering to give his pictures an authentic looking craquelure. There is little on 5b of the typical pattern of cracks on 5a, crazy-paving shapes

mixing with spiral ones from knocks or knots in the canvas, especially in the lower right hand quarter. Van Meegeren's earlier *Disciples at Emmaus*, in contrast, has rather convincing colour and craquelure, maybe because of a bakelite medium in which he was thought to have painted. The technical evidence for this was bitterly disputed however, throughout the nineteen fifties by critics who refused to accept that the *Disciples* was a forgery, and it took more sophisticated analysis of the age of white pigment in 1967 to convince everyone.[30] The nature of the medium of 5b is not known, since no such sophistication was needed to reveal it for what it is.

6a ADAM FRANZ VAN DER MEULEN
1632 – 1690
Landscape with Louis XIV on horseback
oil on canvas, 56.8 × 78.7

- The Bowes Museum, Barnard Castle

6b ADAM FRANZ VAN DER MEULEN
1632 – 1690
Cavaliers and Horses before a Thatched Inn
oil on canvas, 59.1 × 76.8

- The Trustees of the Chatsworth Settlement

The effects of darkened varnish and of the conservation process of lining are apparent in a comparison of two seventeenth century landscapes.

The most obvious difference between the paintings is that 6b, which is from the lenders' reserve collection and is awaiting conservation, is much darker than 6a, which has recently been cleaned. With its old discoloured varnish dissolved away, clear blues and whites are revealed.

Both paintings have in the past been lined – a process in which a reinforcing canvas has been attached to the back of the original canvas, by forcing adhesive from the back through both. It is extremely rare for oil paintings of this age to have been spared this procedure. Until recently, the reinforcing canvas was usually added without first removing earlier lining canvases, and it is not uncommon to find three or four canvases glued together supporting one painting. Unfortunately this meant that great pressure and heat were required to force the adhesive through the package of canvases, and the texture of the paint was often flattened in the process.

6a has survived the treatment unusually well. The bright touches of highlight, in the cavalier's costume or in the tail of his horse for instance, still show much of the sharpness of the tiny ridges left in the paint when first applied. The effect of oil paint depends upon the play of light on such textures in part.

The condition of 6b is much more usual. Lining pressure has rounded the touches of heavy paint, and even impressed the weave of the canvas into the paint, in the ground just below the principal cavalier. There are no hair lines of the brush in the paint of the horse's tail, except in the bottom inch or so, where the paint is overpaint added by a restorer. There is a colour difference between this paint and the original which ageing, since the restoration was done, has brought out, and the craquelure of the original paint can be seen on very close examination not to extend into this area of recent paint. As often happens, there is quite a lot of other overpaint on the picture, because in addition to being squashed by lining the paint has been thinned in parts by abrasive cleaning. In the middle distance the paint is so thin that a whole row of horsemen have almost completely disappeared.

Nevertheless, 6b is still a painting of considerable quality, which will be apparent when its turn comes for restoration.

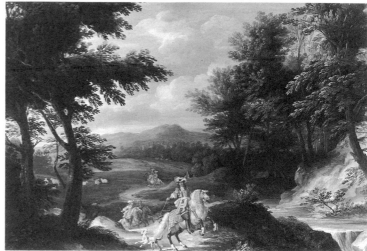

6a

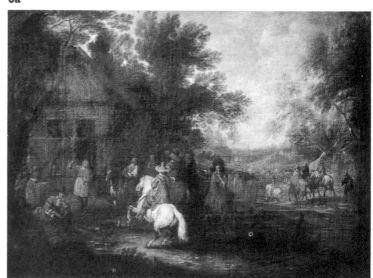

6b

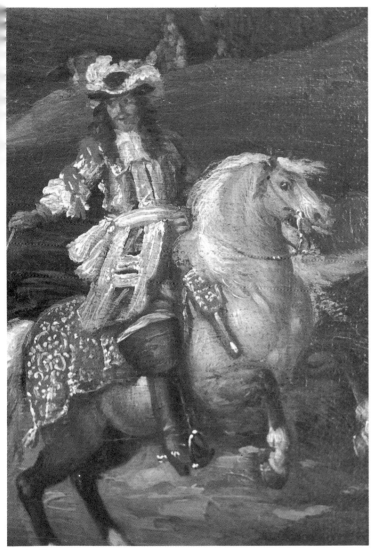

6a *detail*

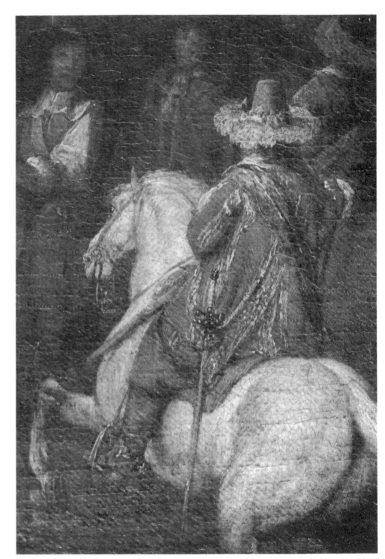

6b *detail*

7a JAN VAN OS 1744–1808
Flowerpiece
oil on panel, 43.8 × 35.6

• Bradford Art Galleries and Museums

7b Imitator of JAN VAN OS
Flowerpiece
oil on panel, 47 × 35.6

• Bradford Art Galleries and Museums

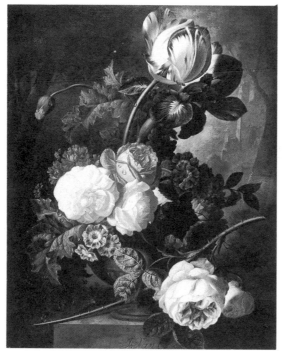

7a

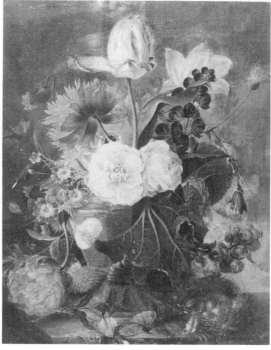

7b

What at first glance appears to be a pair of pictures turns out to have involved three different painters.

Both paintings were bequeathed to the lenders in 1960, though for how long they have been used as a pair is not known. There seems no reason to doubt the authenticity of 7a. As in 5a the artist has achieved effects of light by building up the paint surface in layers of paint of varying transparency. This gives a film of oil which in comparison with the size of individual grains of pigment is quite thick yet surprisingly transparent. Light is reflected within and from it in a complicated way which has enabled the artist to imitate the subtleties of reflection of light from real objects. The subdued background turns out to contain a surprising range of tones, darker to the left and paler to the right, against which the bright flowers are cleverly silhouetted, pale edged leaves to the left, shaded ones to the right. The effect is to push the flowers into prominence.

7b also has a predominantly dark right side to the bunch of flowers and brighter leaves to the left, but the background does nothing to pick up the contrast. It may originally have done so. The present dark background is crude overpaint which stops with a ragged edge to reveal a bit of paler ground to the right, below the middle of the picture. No part of this painting has the delicacy and minuteness of 7a, as a comparison of the petals of the tulips and the waterdrops shows. However the tulips even in 7b, are much more delicately done than the cabbagy white flowers in the middle of the picture. The whole area of these flowers, and a patch to the right below them, seems to have been damaged and repainted in a way quite unlike that of the other petals, with highlight colour simply mixed on the palette and then applied in rough strokes on top of the dirty coloured mid-tone. The white petals in 7a have been built up in transparent layers of paint which distinguish between light reflected brightly from their edges, repeated coloured reflections deep within the flowers, and light transmitted through the petals. Soft shadows reveal their delicately ribbed texture.

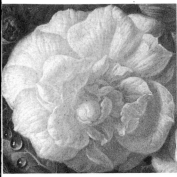

7a *detail*

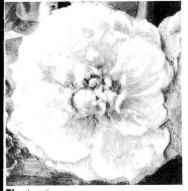

7b *detail*

8a J. M. W. TURNER 1775 – 1851
**The Porch of Great Malvern
Abbey, Worcestershire** 1794
watercolour over pencil,
32.1 × 42.9

• Whitworth Art Gallery, University
of Manchester

8b J. M. W. TURNER 1775 – 1851
**The Chapel, Hampton Court,
Herefordshire** 1795
watercolour over pencil,
31.8 × 42.4

• Whitworth Art Gallery, University
of Manchester

A comparison which shows the
transformation of watercolour by the
action of light.

Both watercolours were painted when
Turner was about twenty. Their original
colour schemes were never the same,
but both would have been constructed
around a dominant contrast of yellows
and blues, and much of the blue has
gone from 8a. Its paper has discoloured
as well.

Turner's watercolours of this time
imitate effects of established artists of
the period, especially in these instances
Edward Dayes, a painter of
architectural scenes. The tops of the
battlements of 8a and of the turrets of
8b are rather bluish and dark. In
contrast the façade masonry of the
porch of 8a and around the great end
window of 8b, is pale and yellowish.
This device of giving buildings dark tops,
usually silhouetted against pale sky, and
light lower masonry often standing out
amidst rather darker surrounding detail,
is a decorative trick which Turner
developed from the rather bluish
atmospheric upper masonry of
watercolours by Dayes. He continued
to play with variations of it throughout
his career, earlier on mostly with

contrasts of dark and light, latterly
more specifically with contrasts of dark
blue and pale yellow.

The effect is subdued in 8a by the
extent to which light has darkened the
paper in comparison with the bright
white paper, recently cleaned, of 8b.
The sky of 8a, was probably also much
bluer. This is not quite certain, but a
very common sky mixture at the time
was indigo and indian red. The indigo
has often faded, leaving a pinky brown
coloured sky as in this painting. The
other blues, in the buildings and
landscape, are of different pigments and
have lasted better. The rather thundery
effect of the scene would not then be
intentional.

9 Imitator of THÉODORE GÉRICAULT
1791 – 1824
**Grey Charger Harnessed
with Blue Trappings**
oil on canvas, 31.1 × 35.6

• The Burrell Collection, Glasgow
Museums and Art Galleries

A forgery, identified on stylistic
grounds, painted to complement
authentic pencil studies.

This horse with its elaborate
accoutrements appears in pencil on a
page of a Géricault sketchbook,[31] in
profile, and the forger has just angled it
to include studies of front and hind legs
in separate sketches on the same page.
One of the artist's lithographs[32] includes
a similarly harnessed horse, and there
would be nothing surprising about
finding an authentic painting related to
it and the drawings. This is not it
however. Géricault only used such thick
freely applied paint for dramatically
active romantic scenes, and in all his
painting made every touch of thick
paint work in emphasising details of the
shapes of his subjects. The blotches of
thick paint on this horse's legs do not
work like this, and for anyone
unfamiliar with trappings, the picture
gives few clues about the structure of
the complicated accoutrements.

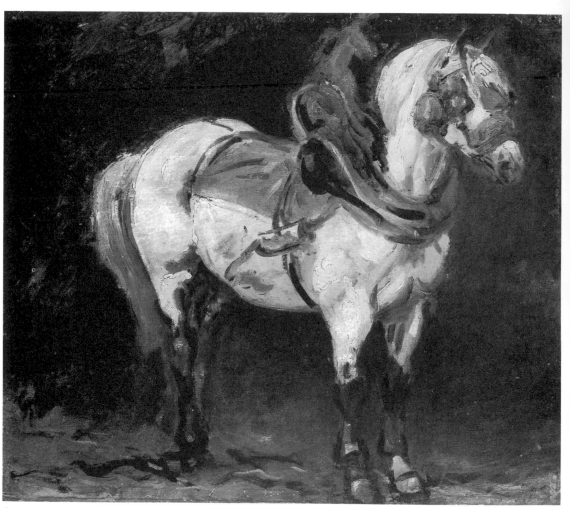

9

GERICAULT a sheet of sketches (fol. 38 recto)
from the album in The Art Institute of
Chicago.

10a JOHN CONSTABLE 1776–1837
Willy Lot's House 1816
oil on paper mounted on canvas
19.4 × 23.8

- Ipswich Museums and Galleries

10b Imitator of JOHN CONSTABLE
Cottage near Bergholt
oil on panel, 25 × 32
- Nottingham Castle Museum
 and Art Gallery

10c Imitator of JOHN CONSTABLE
On the Stour near Bergholt
oil on panel, 26.6 × 36.8
- Nottingham Castle Museum and
 Art Gallery

An authentic sketch of the scene on which *The Haywain* is based, compared with two crude forgeries, revealed by historical and stylistic evidence.

The two forgeries were given to the lenders in 1909 as Constable sketches by James Orrock, a prolific artist and dealer who has recently been shown[33] to have enjoyed a rather relaxed approach to the question of imitation. He explained in a lecture that since artists often made replicas of their own paintings, there is no harm in someone else helpfully doing some more for them. It comes as no surprise to hear that a Turner collector wandering around Orrock's house came across a Turner copy with the paint wet beside the original, or that Orrock did not hesitate to sell his major patron, Lord Lever, 60 'Constables', in addition to one thousand genuine Orrocks. It is not known whether Orrock painted all the imitations himself, but whoever painted these two panels, it was not John Constable.

Constable's freely handled paint disguises the amount of information in his paintings about the shape of

10b *detail*

10c *detail*

everything shown, the geography of the landscape, or the prominences and recesses of foliage or buildings. He depended upon this complicated structure for the sudden effects of light he wanted to catch, and for sudden bright glimpses of distance through gaps. In the authentic sketch, though rather smaller than the forgeries, the lie of the land is precisely recorded. We are quite clear about the angle of the bank to the left, sloping down from the level of the palings in front of the cottage to the water's edge, and could make an estimate of the gap between the cottage and the dark trees beyond, as well as the distance of the two fields which rise beyond the trees. In both forgeries the bridge cuts across the scene so as to save the artist from the trouble of showing just how the river flows through the landscape, and all the structures are fudged. Is the chimney in 10b perched on top of the roof, or is the base of it hidden lower down the far side of the roof? Does the conical thatching of the lower roof in 10c go right up to the eaves of the upper roof, or is there a triangular, flat gable end above it? The barge in 10b is too big to go easily between the bridge supports, yet the figure in it would be very small if he stepped onto the bridge.

In order to catch the effects of light, Constable used quite thick paint for emphasis in his sketch, but elsewhere the paint is fairly thin. It has been put on with many different strokes – short straight strokes following the line of the roof to the left, sinuous swirls for the bright clouds, little touches for the broken highlights in foliage. In the longer strokes the unbroken lines of the hairs of the brush show that, once applied, the paint was rarely disturbed. As a result the paint does not just represent the scene, but has wonderful tiny patterns of its own at the same

time, which still fit in with what is shown.

In contrast the thick, oily paint of the muddy forgeries has been meaninglessy churned about, without suggesting any structure in the scene, especially for instance in the sky of 10c, and in the Disney-like thatch which burdens each sagging cottage.

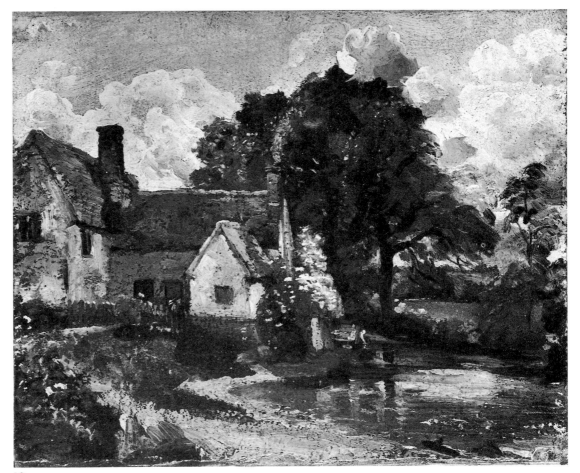

10a

11a JOHN CONSTABLE 1776 – 1837
Clouds and Sky, Tree at Right
oil on paper laid on board,
24.1 × 29.8

- Royal Academy of Arts

11b LIONEL CONSTABLE 1828 – 1887
Study of Clouds with a Low Horizon
oil on paper on panel, 22.8 × 28.9

- City of Bristol Museum and Art Gallery

Stylistic comparisons distinguish cloud studies by John Constable and his son Lionel.

It had been known for a long time that several of John Constable's descendants were also occasional painters, but the characteristics of Lionel's style only begun to be identified after the major Tate Gallery Constable exhibition of 1976, which involved inspection of a huge number of works.[34] The key piece of evidence was historical. The handwriting in a sketchbook attributed to John in the Staatliche Museen in East Berlin was shown by comparison with family papers to be Lionel's not John's. A date, '19' (for 1819) on one of the drawings in the book, which would be right for an attribution to John, was also shown to have been forged by scratching out part of a date '49', for 1849 – appropriate for Lionel, but a dozen years after John's death. Oil paintings previously attributed to John, but closely based on drawings in the book, could then be attributed to Lionel. Others were shown to bear his hand-writing, or to correspond with photographs which he had taken in the eighteen fifties. If John had done the oil paintings many years earlier even from the very same spots where Lionel made his sketches and photos, the foliage could not have corresponded as

closely as it does to that in Lionel's drawn and photographed studies.

On the basis of the small body of work certainly attributable to Lionel on these historical grounds, it was possible to identify stylistic characteristics by which other paintings previously given to John could be identified as Lionel's. 11b is one of them. His skies have a slightly pinky mauve colour in comparison with his father's, and are less dramatic, with thinner paint, usually applied in more even loops and strokes than John's restless flourishes. Compare the rather rounded bright clouds in 11b with those of 11a, made up of little strokes of many different shapes. The direction of the strokes in John's sky also gives an impression of changing wind direction which we do not see in Lionel's, especially the diagonal ones at the bottom to the left, and then running at right angles to them those just above and to the right of the bright cloud in the centre. Nor was Lionel as interested as John was in using the prominences and recesses of cloud and foliage shapes to catch the light, or leave pools of shadow. Nevertheless, Lionel was a considerable, sensitive painter in his father's unaffected style.

11a

11b

12a SAMUEL PALMER 1805 – 1881
Landscape with a barn, Shoreham
watercolour, body colour and ink on paper, 27.8 × 45

- Victoria and Albert Museum

12b TOM KEATING. 1917 – 1984 in the manner of Samuel Palmer
A Barn at Shoreham
Sepia mixed with gum and heightened with white, on paper, 26.2 × 37.2

- Trustees of the Cecil Higgins Art Gallery, Bedford

12c TOM KEATING 1917 – 1984 in the manner of Samuel Palmer
Shepherd and his flock in a hilly landscape with Shoreham Church
sepia ink, varnished, 19 × 23

- Mrs Frank Norman

Two forgeries by Tom Keating, distinguished on stylistic and historical grounds from an authentic Samuel Palmer.

Palmer painted all his most famous pictures around the Kent village of Shoreham in the late eighteen twenties. The earliest of them are fantasy landscapes in a mannered but extraordinarily intense style, in a mixture of ink and paint, later varnished. 12c is an imitation of one of these imaginary landscapes, into which Palmer, like Keating, sometimes added real details like the church spire. Later at Shoreham Palmer did a number of more naturalistic, though still wonderfully intense studies of real scenes, in a style which combines very freely ink drawn or wash painted areas with patches of the finest detail, rapidly applied in spots of body colour, or the finest of spidery ink lines. 12a is one of

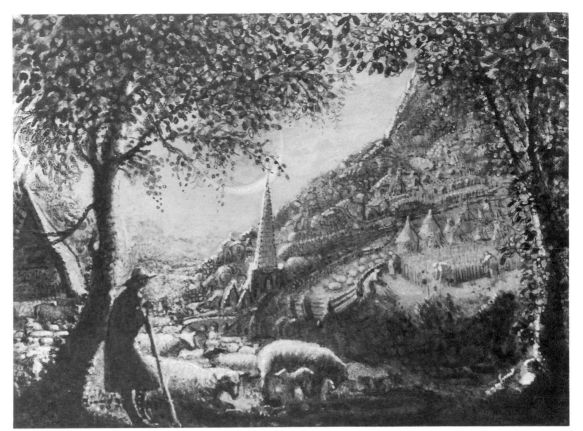

12c

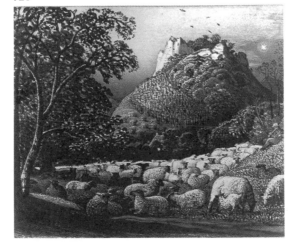

PALMER *The Flock and the Star*
Ashmolean Museum, Oxford

these paintings, and perhaps one of the most beautiful of all English watercolours. 12b is obviously based on 12a, but is a bit of a muddle, since Keating also copied the barn doorway through which his picture is seen from another Palmer painting,[35] and then added, as he did in 12c, one of Palmer's fantasy moons, but this time rather inappropriately put into this more naturalistic scene. (see illustrations page 9).

Both forgeries fail stylistically because though they have a certain panache, they miss Palmer's absolute passion for eccentric shapes. In 12a the corrugations of the different tree trunks, the eiderdown-like quality of the bright cloud and the minute chaos of growths sprouting on the thatch are all set down by using the paint and ink in a huge number of different ways. Although the drawing is often freely done, the lie of the landscape down to the gate and beyond is so defined that it would be possible to make a map of it, marking the position of each tree and the slope of the ground. This is all conveniently fudged in the bravado of 12b, in which the carts, firmly on the ground in 12a, seem to be floating about in their shed. What happens around and beyond the gate is lost in mystery. Similarly in 12c the recession of the landscape beyond the hill immediately to the right of the shepherd is fudged, as is the way the branches are attached to the droopy trees. Palmer loved every wrinkle of such things. He also liked fine-grained papers, without the prominent laid lines of the sheet used for 12b. (see cat. 23a).

It is easy to make such judgments in retrospect. Though 12c was never used to deceive, and was given by the artist to Geraldine and Frank Norman, the journalists who first identified him, 12b

was one of the most successful of Keating's forgeries.[36] Though doubted by some from its first appearance in a country sale, it made its way up market to be acquired by the lenders from Bond Street in 1965, with the approbation of advisers in the Tate and British Museum. Far too many Shoreham period Palmers then began to circulate for eyebrows not to begin to raise, especially after a really bumper contingent of unknown visionary scenes appeared on the market in 1972. The agonies of the trade and the critical and scientific differences which followed rather faithfully echoed those in Berlin during the Wacker affair forty years earlier. A consensus against the pictures emerged after forensic evidence (from Julius Grant, the paper scientist who also exposed the Hitler Diaries) seemed to indicate a date for the paper too recent for one of the drawings. Assiduous sleuthing then led the Normans to Keating. Like many forgers he was first an artist and restorer, who since the fifties had fed onto the market hundreds of fakes of dozens of artists.[37]

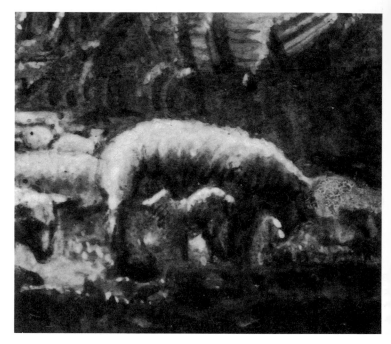

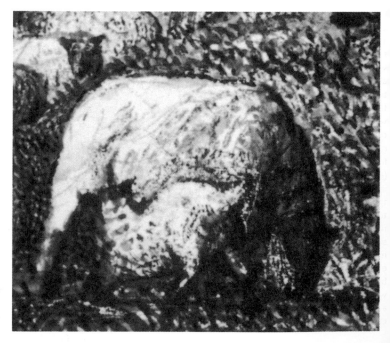

Details of **12c** (above) and *The Flock and the Star*

DON'T TRUST THE LABEL • 33

13a RICHARD PARKES BONINGTON
1802 – 1828
The Grand Canal, Venice 1826
oil on primed mill board,
35.4 × 43

• Private Collection

13b RICHARD PARKES BONINGTON
The Grand Canal, Venice 1826
oil on canvas, 30.5 × 42.5

• Nottingham Castle Museum and
Art Gallery

13c PIERRE-JUSTIN OUVRIE 1806 – 1879
The Grand Canal, Venice
oil on board, 27.6 × 43.8

• Bowes Museum, Barnard Castle

Bonington is seen at his best by
comparing a painting done whilst in
Venice with a replica, and with a similar
view by a lesser known
contemporary.[38]

It is known that Bonington was painting
on millboard whilst in Venice so that
13a on these grounds alone would be
the best candidate for the original
version, since 13b is on canvas. This
also fits in with the pencil lines under
the paint but not followed by it, above
the second building from the left in 13a,
which would be an improbable change
of mind in a replica. It is also a much
more boldly painted picture. The pale
façades of the buildings to the left
(except at the extreme left) are painted
in broad strokes of heavy paint, with
the details swiftly added in thin glaze on
top. The same buildings in 13b are
more laboriously done. Although the
skies of both pictures share a general
massing of cloud, there is a greater
effect of volume to the bright cumulus
below the blue in 13a, and at the level
where the sky of 13b is cut off, 13a has
a row to left of centre of upward
curving strokes of paint, suggesting a

low level of diffuse cloud not
distinguished from the rest of the sky in
13b. The replica in general does not
show at its best Bonington's ability to
use the most fleeting touches of paint
without losing the structural details of
what he was painting. The bright prow
ornament on the gondola to the right
of centre, for instance, which is well
defined in 13a, becomes in 13b a touch
of paint which could equally well
represent some feature in the water
below the distant buildings.

Bonington did different versions of a
number of his paintings and there
would have been nothing unusual about
a commission for a replica of 13a once
he had returned to his studio in Paris.
Just possibly, it may be by a
professional copyist, though the
difference in tone of the lower sky in
the two paintings would be an odd
variation for a copyist to have
introduced.

Ouvrié's painting from a nearby spot
(from which Bonington also painted on
another occasion), has never been put
forward as anything other than what it
is, and its inclusion in this exhibition is a
little unfair. However it stands here for
the many such townscapes with
romantic associations, made fashionable
partly by Bonington, painted by his
contemporaries but now often put
forward in his name. Ouvrié's
conscientious effort even has a rather
similar sky to Bonington's view, but
clearly lacks his flourishes of paint with
their own qualities of pattern which still
suggest structure, light and breeze.

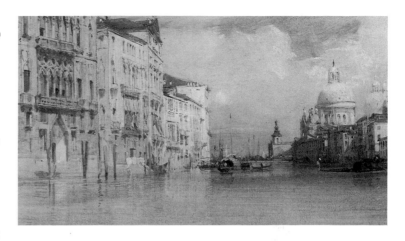

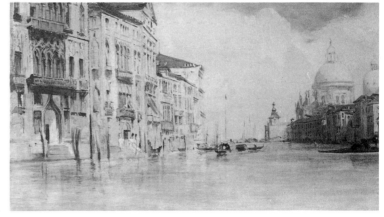

Details from **13a** (top), **13b** (centre), **13c**
(bottom)

14a HONORÉ DAUMIER 1808 – 1879
Good Colleagues (Bons Confrères) 1860 – 70
Pen and wash, 26 × 33.6

- The Burrell Collection, Glasgow Museums and Art Galleries

14b After HONORÉ DAUMIER
The Two Advocates
wash, charcoal and chalk on paper, 24.8 × 21.6

- The Burrell Collection, Glasgow Museums and Art Galleries

A drawing which on stylistic grounds appears to be a copy compared with an authentic drawing by Daumier.

Daumier always wanted to be recognised as a painter in oils, but was famous as a social and political caricaturist for the liberal press. His caricatures are merciless, though drawn under pressure of time with immense panache. He did numerous studies of the legal system and its victims, like the peasant to the right in 14a contrasted with lawyers for whom it is all a game. In both these drawings they seek to distance themselves by elaborate mutual courtesies from their theatrically adversarial bouts in court. 14b however is thought to be a copy in reverse rather than a study by Daumier, of figures from a more finished drawing.[39] These lawyers do not seem to share the same speed of execution combined with anatomical accuracy which their colleagues enjoy in 14a. Notice the strange bulge on the hand of the right hand figure, as he raises his hat. Nor do the figures have the strength of characterisation of the figures in the original drawing, or in 14a, in which even the lawyer with his back to us is a vivid personality. Notice especially the noses, whose idiosyncracies are

minutely observed and contrasted in the two finished drawings. The noses of the two figures in the less finished drawing are rather similar in shape.

All three drawings are signed, and it is tempting to see a little hesitation in the letterforms of the unfinished drawing. Signatures offer less clues than drawings themselves, however, and are less useful in the study of art than is often thought. It is not uncommon to find a spurious signature on a genuine picture.

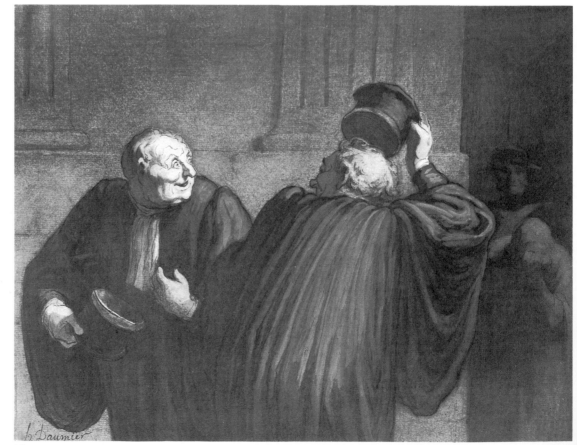

14a

below

DAUMIER *Mon Cher Confrère* c. 1860

Felton Bequest 1922, reproduced by
permission of the National Gallery of
Victoria, Melbourne

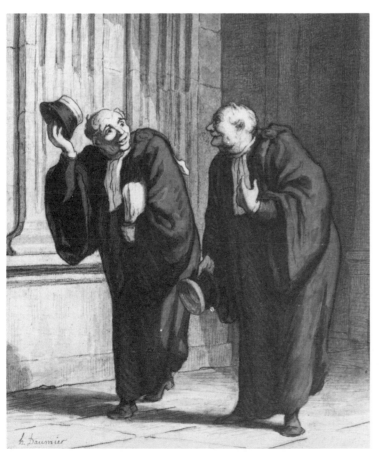 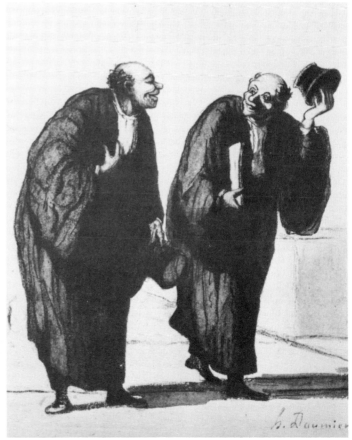

14b

15a CAMILLE-JEAN-BAPTISTE COROT
1796 – 1875
Souvenir d'Italie
charcoal on buff paper, 31.6 × 48.6

- Lent by the Syndics of the Fitzwilliam Museum, Cambridge

15b Imitator of COROT
Nocturne
charcoal on blue paper, 30.5 × 47.6

- Whitworth Art Gallery, University of Manchester

15c Imitator of COROT
St Brevin près St Nazaire
gouache, 15.9 × 28.1

- Whitworth Art Gallery, University of Manchester.

Historical and stylistic evidence distinguishes an authentic drawing from two forgeries.

15a is an example of a drawing which can be traced with confidence all the way back to the artist's own collection, and the sale of his work in 1875. 15b and 15c however come from a huge collection of over 2000 drawings, supposedly the most intimately private work of the artist, which had escaped the assiduous cataloguing of his other work by friends because, it was suggested, the artist had perhaps left it with a doctor with whom he had stayed. This collection, having passed through the hands of a certain Jousseaume, appeared in London, where the keeper of the British Museum print room, Campbell Dodgson, greeted it with cautious enthusiasm, after an inspection of a first instalment 'in a squalid bedroom in Soho'. The collection was bought by a London dealer and published in an elaborate catalogue.[40] The very uneven quality and the improbable provenance only slowly led to a consensus that the whole thing was a huge fraud.[41]

15b, with its bold diagonal hatched shading in the trees is at least an imitation of the drawings Corot was doing around 1870, though in a smudgy style which is really more like a reminiscence of his late oil paintings than his authentic charcoal drawings. These are, like 15a, bolder, with the softness of the charcoal enlivened with fine lines, like those which rise diagonally to the left from the middle of the drawing, and prominent branches.

15c is like nothing Corot ever painted. He did not paint in gouache at all and all the drawings in this medium in the collection bear bizarre inscriptions on their reverse sides, intended to suggest that the collection was of the most private kind, explaining the inclusion in it of an entire body of work in a medium which the artist otherwise neglected. The inscription on 15c simply reads, in French, 'St Brevin près St Nazaire in the distance there is a crowd of houses but they are so far away that my goodness I am not going to do them.' On another drawing we are supposed to find the honest painter noting that he is 'all aroused, and all because I have just seen a pretty little spring tease'. The forger evidently felt Corot did not get enough of this kind of thing in existing biographies, since on another occasion we find him wondering 'is she going to get into the water if so I hope she gets a move on which will give me an agreeable interlude'.

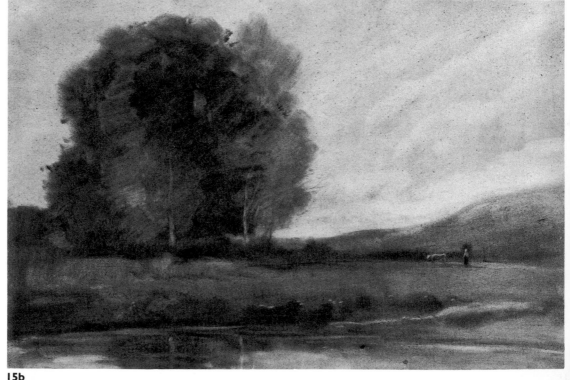

15b

15c

15a

16a EUGÈNE BOUDIN 1824–1898
Trouville Harbour
oil on canvas, 38.4 × 54.5

• Manchester City Art Galleries

16b Imitator of EUGÈNE BOUDIN
The Port of Antwerp
oil on board, 25.4 × 39.3

• Tim and Nancy Yates

A comparison of a painting by Boudin with an imitation helps to define the characteristics of his style.

Neither of these pictures has been scientifically analysed, and the history of neither can be traced back very far, 16a came to the lenders in a bequest in 1941, and 16b was bought at a Manchester auction in about 1980. The firm attribution of 16a and rejection of 16b are both made on purely stylistic grounds.

Boudin spent most of his life living in and painting French coastal towns, and the bright naturalism of his scenes anticipated the painting of the Impressionists, especially the young Monet, who met Boudin in Le Havre in about 1859. None of the cool blues and silvery greys which Monet would have admired in 16a have been captured in the strange warm colours of the forgery, which perhaps is based in colour on a memory of a Boudin with discoloured varnish, or a poor warm-toned colour reproduction. The application of paint in 16b is also unlike that in 16a. In the forgery it has been put on entirely in small touches, mostly a centimetre or so long, in rather oily paint, so that the edges of the strokes and the marks of the brush hairs are rounded when visible at all. Boudin's paint is drier, with long thin strokes. This is very clear if the reflections of the three sailing ships, seen head on to the right of the forgery, are compared

with those of the tall ship in 16a. Boudin's paint is more appropriate to his subject. The bright blue of his sky includes, besides long thin strokes, a patch of oily, intense blue paint just to the right of the brightest cloud, and little strokes of darker blue higher up. The effect is of breeze. The rather even dabs of paint of different colours in 16b are recognizably in the manner in which modelling has been taught in English art schools, especially in the last forty years.

The forgery seems closely based on a known painting by Boudin of Antwerp harbour in 1871,[42] but with the positions of the three sailing ships, seen head on to the right, and of the ship seen in profile in the centre reversed. There might however be a lost original by Boudin with this arrangement which the forger has simply copied.

16a

16b

16a *detail*

16b *detail*

17a FORD MADOX BROWN 1821 – 1893
Cromwell, Protector of the Vaudois 1877
oil on canvas, 86 × 107

• Manchester City Art Galleries

17b FORD MADOX BROWN
Cromwell, Protector of the Vaudois 1878
oil on canvas, 78.7 × 96.5

• Nottingham Castle Museum and Art Gallery

Two paintings which testify to the willingness of a Victorian artist to replicate his own work slavishly for a fee.

It is May Day of 1658, and as Cromwell, to the right, impatiently indicates the trouble zone on the map, the blind Milton dictates a protest to Louis XIV at the ill treatment of the Protestant Vaudois of Piedmont, whilst Andrew Marvell writes it all down. Brown painted it for his Manchester patron Charles Rowley, who wanted a painting of Milton,[43] and it occupied much of his time from February to October 1877. So moved by it was another friend, Albert Wood, that Brown had to devote much of December to July of the following year on a replica for him.[44] Many of the most famous of the pre-Raphaelite paintings also exist in more than one version, but this replica is a particularly exact one, save for the omission of two little diagonal pieces of leading in the window. The texture of the paint, which never had much chance in the face of Brown's laborious search for truth to detail, is exceptionally dry and tortured in 17b.

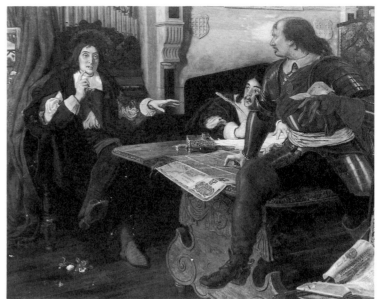

17a

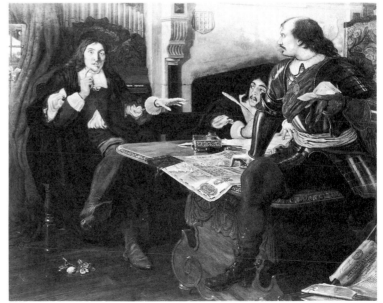

17b

18 Imitator of VINCENT VAN GOGH
1853 – 1890
The Sea at Saintes Maries
oil on canvas, 44.5 × 57

• Rijksmuseum Kroller-Muller. Otterlo

A painting whose authenticity might never have been doubted but for its provenance.

The painting was bought by Frau Kroller, whose Van Gogh collection forms the basis of the Kroller-Muller Museum, on specialist advice, even though it came from a dealer suspected of dealing in forgeries. Even when suspicion hardened to conviction she never admitted to doubts about this picture. The scholar whose Van Gogh catalogue is now standard also kept changing his mind about it. At first he accepted it,[45] then decisively rejected it[46], then had second thoughts[47], and only finally listed it for his catalogue amongst the spurious works.[48]

The affair of Otto Wacker,[49] dancer turned art dealer, scandalised Berlin from the opening of his gallery with a show of a remarkable number of Van Gogh's in 1927, to his conviction for their forgery five years later. A consensus of opinion against the pictures grew only slowly, in the face of the quality of the best of the forgeries, Wacker's mysterious provenance for them – a Russian aristocrat in Switzerland whose family in Russia had conveniently to be protected by anonymity – and the hilarious inability of critics, scientists and officials to agree on anything in court, until the despairing judge proposed handing critical assessment over to a policeman. Final conviction followed firm opinion against the paintings from the Director of the National Gallery in Berlin, Justi, and a demonstration that x-ray photos (used in court for the first time in an art

case) showed Wacker's paintings to have characteristics unlike those of better authenticated Van Gogh's. Wacker's case was weakened by his inability to produce the mysterious Count – by now allegedly fled to Cairo – nor was it helped by the discovery in his brother Leonhard's taxidermy premises, during a police raid, of one of Wacker's Van Gogh's, with a still wet copy beside it.

The *Sea at Saintes Maries* is very closely based on an authentic drawing, done at Saintes Maries in the Summer of 1888,[50] but the painting is quite unlike the seascapes which Van Gogh is known to have done in oil at the time. These are either of brightly coloured boats drawn up on the beach, or seascapes in rather subdued blues and greys. Van Gogh particularly mentioned these colours in a letter at the time, in which he discussed two seascapes in oil which are known to survive,[51] including one based on the same drawing. These paintings have paint applied in a wide variety of ways, and do not show the intense, swirling patterning of short, separated strokes in bright colours, which we see in this painting, and which is characteristic of later work by Van Gogh. No authentic example is known of a later work of Van Gogh based so closely upon a much earlier drawing.

It is not known who painted Wacker's forgeries. In addition to his brother's apparent skills, his father was an artist and restorer and his sister painted as well. Several forgers might have been involved, since the quality of Wacker's stock varied, and critics were also able to point out in some of the forgeries (though not in this picture) the manifestly phoney procedure of painting the whole scene in white, just to get the relief of the paint right, and then just adding colour on top.

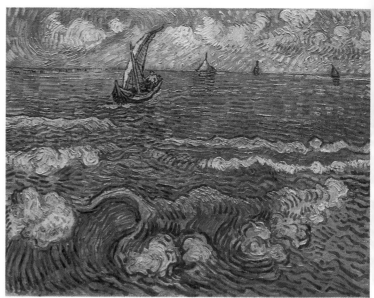

18

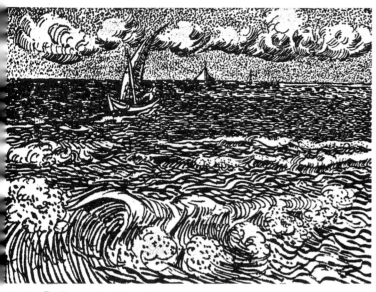

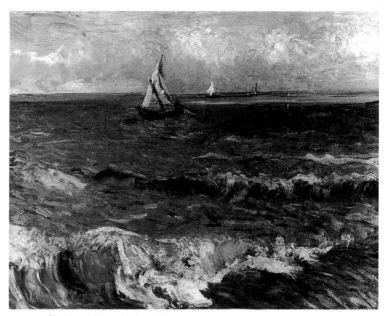

VAN GOGH *The Sea at Saintes-Maries* 1888
ink drawing
Private Collection

VAN GOGH *The Sea at Saintes-Maries* 1888
Stedelijk Museum, Amsterdam

left
VAN GOGH *The Olive Orchard* 1889
Chester Dale Collection,
National Gallery of Art, Washington

19 Imitator of PAUL GAUGUIN
1848 – 1903
En Bretagne
watercolour, bodycolour and
gold paint, 37.7 × 27

● Whitworth Art Gallery,
University of Manchester

A watercolour suspected as a forgery
on stylistic grounds.

This painting, whose history before its
purchase for the lenders from the
Leicester Galleries in 1926 is unknown,
was unquestioned until Douglas
Cooper, working on a Gauguin
catalogue, dismissed it with vigour in
private correspondence with the
lenders in 1980, pointing out that the
signature and gold paint are unusual,
and that all the figures and the
landscape are to be found in other
paintings done by Gauguin in Brittany in
1889.[52] The scene as a whole, cow
included, reappears in the bottom right
hand quarter of a painting in the
National Gallery in Oslo.[53] The rather
odd figure to the right, (who looks in
this drawing as if drawn by the
American humorist James Thurber) also
turns up in a painting in a private
collection.[54] Something like the strange
whirligig bush above the figure to the
left appears in a painting in the
Niarchos collection.[55] The combination
of such a systematic re-use of figures
with the other unusual features is
strong circumstantial evidence of
forgery, in the case of a painting which
is also not spectacularly effective,
though not all art historians are
convinced.

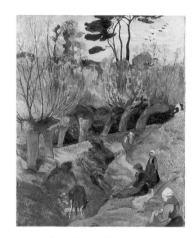

GAUGUIN *The Willows* 1889
National Gallery, Oslo
above whole picture, *below* detail

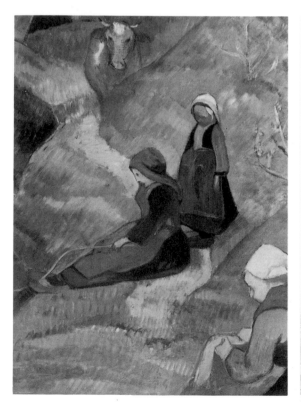

19

20a ELMYR DE HORY died 1976
Boating Scene in the manner of
Dufy, after 1968
oil on canvas, 39.2 × 57.3

- private collection

20b RAOUL DUFY
Henley, Régates aux drapeaux
1935–52
oil on canvas, 90 × 117

- Musée d'Art Moderne de la Ville
de Paris

A known forgery, distinguished from an
authentic work on stylistic grounds.

The colours of 20a are rather chalky
for Dufy, but otherwise this is not an
unconvincing painting in comparison
with his work of the mid thirties when
he began 20b. Dufy made at least one
drawing and several paintings of the
boating scene at Nogent-sur-Marne on
which the forgery is based.[56] De Hory
has reduced the scale of the view by
substituting a small bathing house for
the boat house which appears in Dufy's
pictures, and more drastically a rather
odd archway with a bobble on top for
the viaduct, on which Dufy sometimes
showed a train passing. Otherwise the
most uncharacteristic features of the
forgery are the wavy lines in the water.
These are indeed a known Dufy
notation for waves, but always in sea
scenes, not river scenes. Such
consistency on Dufy's part, is an
indication of the discipline behind the
deceptive freedom of his style, which
enabled him to handle the vivid
exuberance of 20b. De Hory had to
play very safe with 20a for it to
succeed as well as it does.

Nevertheless this is thought to be one
of the paintings de Hory did after his
exposure as a forger in 1968 and the
very best of his work was done earlier.
It is not easy to be too confident about

the details of his career. He seems to
have been a charming fantasist with a
real painterly talent who sold many
forgeries to public museums in the
fifties and sixties. He might perhaps not
have been exposed had not his
associates begun to sell his work in such
huge batches that deficiencies were
bound to be spotted, as happened
most notoriously with the forty-four
fakes sold to the Texas oil man Alger
Hurtle Meadows.[57]

DUFY *The Marne at Nogent* 1935
Gift of Arthur Keating. © The Art Institute of
Chicago, all rights reserved
© DACS 1986

20a

21a ALBRECHT DÜRER 1471–1528
The Visitation about 1504
woodcut, sheet size 30.3 × 21

• Whitworth Art Gallery, University
of Manchester

21b MARCANTONIO RAIMONDI
1480–c. 1530 after Dürer
The Visitation
engraving, sheet size 30.2 × 20.9

• Whitworth Art Gallery, University
of Manchester

A woodcut by Dürer which loses some
of its characteristics when translated
into engraving for a famous pirate
edition.

Dürer had rapidly made a reputation all
over Europe by the time his *Visitation*
appeared, by publishing a series of such
woodcuts, which showed an
unprecedented range of effects, often
on a huge scale by the previous
standards of print publishing. He was
on a visit to Venice when he learned of
Marcantonio Raimondi's pirate edition.
He complained to the authorities for
redress, but in the absence of any
copyright law was able only to oblige
Raimondi to publish his plagiarisms
without the famous AD monogram,
which appears in both these prints.

In woodcut the individual lines have to
be fairly broad for ease of cutting and
to survive the pressure of printing,
since the ink sits on vulnerable ridges of
wood which are left protruding above
the surface of the block. In engraving
the ink sits in lines scratched in a
copper surface, which have to be quite
fine. Raimondi has therefore had to use
many more hatched lines than Dürer in
copying one of Dürer's prints onto a
copper plate. This has given the copyist
some problems. The lines of woodcut
show the overall shape of things, such
as the folds of drapery, but are too

broad to suggest textures. The fine
lines of engraving cannot fail to suggest
texture as in Dürer's print of St
Jerome. 22a The engraver has had no
textures to copy in the woodcut and
the fabrics in the engraving look oddly
rubbery. The difference in technique
has also made it very hard to preserve
the balance of light and dark in Dürer's
print, with its extraordinary effect of
light and air, and the right hand of the
two central figures is no longer in 21b
silhouetted nearly so clearly against the
dark background.

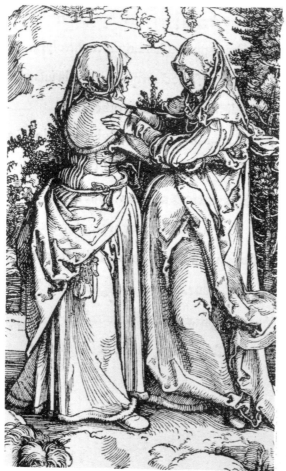

21a *detail*

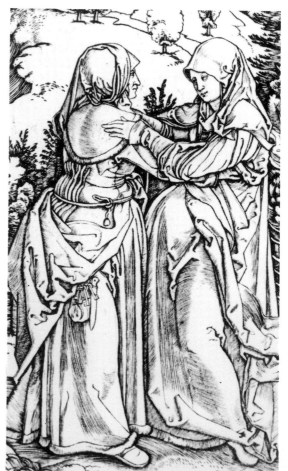

21b *detail*

22a ALBRECHT DÜRER 1471–1528
St Jerome in his study 1514
engraving, sheet size 24.6 × 18.7

• Whitworth Art Gallery, University
of Manchester

22b ALBRECHT DÜRER
St Jerome in his study 1514
engraving, sheet size 24.6 × 18.9

• Whitworth Art Gallery, University
of Manchester

22c ALBRECHT DÜRER
St Jerome in his study
photo-mechanical reproduction of
engraving post 1960, platemark
26.5 × 20.9

Private Collection

A group which compares two
impressions from the original plate, one
of which has suffered damage, with an
impression from a modern photo-
mechanically copied plate.

This is one of the prints which shows
Dürer at the height of his powers, using
engraving instead of woodcut in a print
for the higher end of the print market.
He has used the delicacy of the
engraved lines for a huge range of
textures, from the fur of the animals to
the smooth grain of the timber ceiling,
with effects of sunlight, shadow and
reflected light more carefully recorded
than in any previous picture. These
effects are muted in 22b whose paper
has been darkened and damaged.
There is even a strip missing from the
lower right hand edge, which a restorer
has repaired and filled in with hand
drawn lines. The contrast over the
whole print is reduced. The contrast in
22c, the print from a modern
photographically copied plate, has been
slightly exaggerated. It shows much of
the effect of impressions from the
original plate, however, and the

publishers have been careful to print it
on a paper of the correct type for an
engraving of the period, unlike the
paper of the Rembrandt reproduction,
23a.

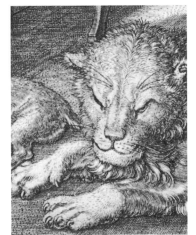

22a detail

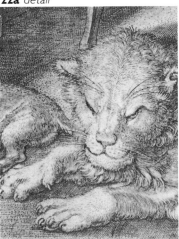

22b detail

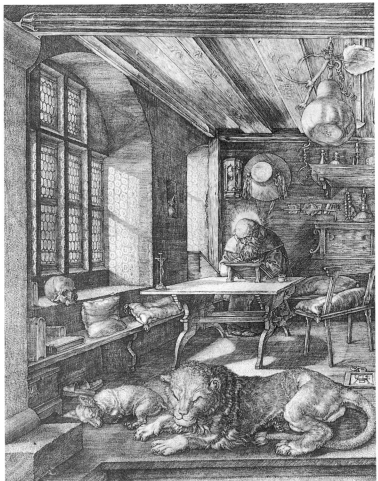

22a

23a REMBRANDT VAN RIJN 1606–1669
Christ Healing the Sick
photo-mechanical reproduction of
etching and drypoint, 1st state,
platemark 27.8 × 38.7

• Mr. and Mrs. E. Sniechowski

23b REMBRANDT VAN RIJN
**Christ Healing the Sick
1642 – 5**
etching and drypoint, 2nd state,
platemark 28 × 39.5

• Trustees of the Chatsworth
Settlement

23c REMBRANDT VAN RIJN and CAPTAIN
JAMES BAILLIE 1723–1792
Christ Healing the Sick 1775
etching and drypoint, final state,
platemark 28.1 × 39.4

• Whitworth Art Gallery, University
of Manchester

Three versions of Rembrandt's famous
print contrast a modern reproduction
with an impression from the plate as
Rembrandt finally left it, and with
another from the original plate as
altered by a dealer.

In this print Rembrandt combined
intense deep shadows with very free
drawing, by mixing etching and
drypoint. For etching the lines are
bitten in the copper plate by acid
where a protective coating on the plate
has been scratched away. Drypoint lines
are scratched directly into the copper
surface with a needle. Then the plate is
coated with a thick ink, and wiped so
as to leave ink just in the lines etched
or scratched in its surface. The ink
transfers to damp paper pressed onto
the plate, and is so thick that the lines
stand just slightly in relief from the
page, and the play of light on the relief
gives deep blacks, as in 23b. 23a
however has not been printed like this

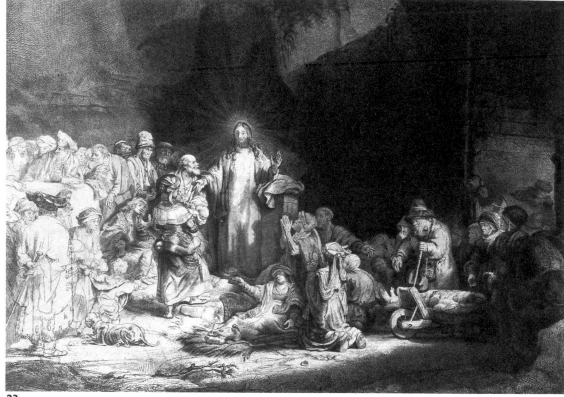

23c

from the original plate, but from a new
plate of a different type made from a
photograph of one of the original
etchings. Various techniques for
reproductions of this kind were
developed in the second half of the last
century. This plate has given only a thin
coat of ink which appears grey in
comparison with that of 23b. The
texture of individual dark lines which
fills even the darkest parts of the
etchings from the original plate has
vanished in the reproduction.

It is also on a different kind of paper.
Paper is made by expelling water from
a pulp lying on a wire tray. The pattern
of the wires remains visible especially if
the paper is held up to the light. The
paper of 23b and 23c was made on
trays of many parallel wires a tenth of
an inch or so apart, laid on top of
more widely spaced wires at right
angles. This kind of paper, called 'laid'
is still made, but larger sheets since the
late eighteenth century have been
generally made on trays of wire woven
into a regular fine mesh. (See
illustrations p 10.) An apparently early
drawing or print, such as 23a, on such
'wove' paper is always a reproduction
or imitation. This sheet has also
discoloured.

23a is a reproduction of the print as
Rembrandt first issued it. It does not
have on the neck of the donkey to the
extreme right the long diagonal lines of

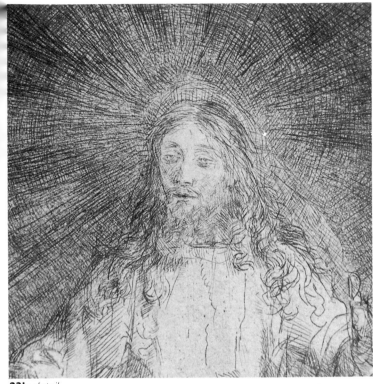

23b *detail*

23c *detail*

shading which can be seen on 23b, which is the second 'state' of the plate. Notice too the heavy lines of thick, blurry ink on the hanging sleeve of the man standing with his back to us at the extreme left of the print, holding a stick. In the original etching from which this reproduction was photographed ink had spread onto the paper from tiny curls of metal pushed up on either side of the scratched drypoint lines. Rembrandt deliberately made the most of these rich lines of burr, but the delicate metal ridges were soon worn down in printing, so that the effect has disappeared progressively in 23b and 23c.

Rembrandt's original plate, very worn indeed, was bought in 1775 by the soldier turned art dealer Captain Baillie, who reworked it to strengthen it, and published impressions with his improvements in 1776. He added a great deal more shading to try to recapture the deep shadows of early impressions, and defined the face and hair of Christ, left expressively sketchy by Rembrandt. Baillie's efforts were much applauded at the time, but most modern critics prefer their Rembrandt un-adulterated.[58]

23a *detail*

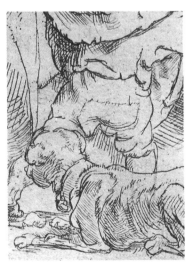
23b *detail*

24a FRANCESCO GOYA 1746–1828

**Because She Was Susceptible
(Por Que Fu Sensible)**

aquatint, first printing, platemark
21.5 × 15.0

- Manchester City Art Galleries

24b FRANCESCO GOYA 1746–1828

**Because She Was Susceptible
(Por Que Fu Sensible)**

aquatint, fourth or fifth printing,
platemark 21.5 × 15.0

- Private Collection

Impressions taken from the same plate
some seventy-five years apart show the
effect on it of repeated printing.

This is no. 32 of Goya's series of
aquatints and etchings of *Caprichos* –
fantasies bitterly critical of Spanish
society of his day. The most famous
print of the series is the *Sleep of
Reason Produces Monsters*, and the
theme of the series is that the
dominance of reason by tradition and
superstition leads to grotesque
unhappiness. Here a young girl's taste
for high living has led to imprisonment
for adultery or prostitution. It is unusual
in the series in that it has no etched
lines in it, only tones of aquatint. In
consequence it has suffered
exceptionally badly in repeated
reprinting, since the aquatint is more
vulnerable than etched lines.

In aquatint printing the ink sits in a huge
number of tiny pits etched in a copper
plate by acid which has been allowed
to percolate its way through a granular
coating on the surface of the plate. The
different tones are made by controlling
the amount of acid which is allowed to
get through to different parts of the
plate. The artist has used varnish to
stop any at all getting through in the
white parts of the picture. The parts
which have printed mid-tone, like the

background and the shadows on the
dress, have been attacked by acid
once, and then protected with varnish
whilst the very dark parts, like the hair
and rat to the bottom right, have been
attacked a second time.

The aquatint had begun to wear by the
end of Goya's first printing of three

hundred sets of the plates in 1799. He
later sold the plates to the Spanish
royal household, who frequently
reprinted them even in the present
century. 24b is probably from a printing
between 18/8 and 1881. The dramatic
effect of harsh light in the cell has been
lost with the failure of the mid-toned
aquatint.[59]

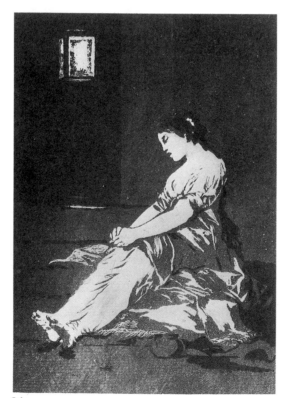

24a

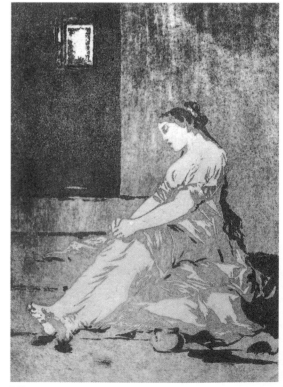

24b

25a FRANCESCO GOYA 1746–1828
You Who Cannot (Tu Que No Puedes) 1799
aquatint with etching, first printing, platemark 21.5 × 15.0

• Manchester City Art Galleries

25b M. SEGUL after Francesco Goya
You Who Cannot (Tu Que No Puedes)
aquatint and etching image, 18.7 × 12.1

• Private Collection

An impression from the original plate of no. 42 of Goya's *Caprichos,* compared with one from a plate copied by hand.

The scene shows a topsy-turvy society, in which men sleep under a burden of ignorance and superstition. Unlike 24a it has etched lines as well as aquatint tones. The tones have been put in with only one exposure of the plate to the acid, but the single resulting tone has been modulated by burnishing down the mass of tiny pits in places, so that they print lighter, for instance in the lower sky, and on the body of the right hand donkey.[60]

The scene was carefully copied onto a new plate sometime after 1850 for 25b, which like the original plate was both etched and aquatinted. The copyist has tried to follow Goya's print line for line, but exact replication would have been almost impossible by hand. On the leg of the right hand figure most of the horizontal shading lines run over the edge of the shin in the copy, whereas they do so only above the knee in Goya's plate. The tone has none of the richness of Goya's and the burnishing has not been allowed to leave hard edges in the copy, as in the lower sky and on the donkey to the right of the original.

25a

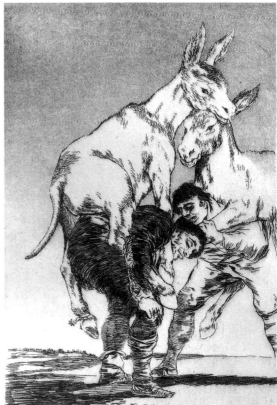

25b

26a Imitator of JEAN FRANCOIS MILLET
1814–1875
The Potato Gatherers
lithograph on blue paper,
34.3 × 51.1 (sheet size)

- Whitworth Art Gallery, University
 of Manchester

26b The original lithographic stone from
which (a) was taken,
23.3 × 32.3

- Whitworth Art Gallery.
 University of Manchester

26c JEAN FRANCOIS MILLET 1814–1875
Sheepshearers, 1846-8
black crayon on beige paper,
30 × 35.5

- City Museums and Art Gallery,
 Plymouth

Historic and stylistic evidence identifies
a lithograph in the manner of Millet as
a forgery in comparison with an
authentic chalk drawing.

Millet made only one lithograph himself,
The Sower, and did not like the result,
so that no impressions of it were issued
in his lifetime. 26b turned up for sale in
1920 and was bought by the Leicester
Galleries in London in 1920. They had
an edition of 200 copies printed on
different coloured papers, apparently
using some kind of intermediate
photographically made plate, since the
image in 26a is in the same sense as
that on the stone itself, instead of being
a mirror image of it as it should be.[61]

The stone was acquired 'from a
member of the Millet family together
with a large number of drawings'. In
retrospect no provenance could be
more ominous, following a police raid
of 1930 on the premises of Paul Cazot,
friend of the artist's grandson Jean
Charles Millet, when several thousand

MILLET *The Sower*
lithograph
The British Museum, London

forgeries of different artists were
discovered, including many of Millet.
The two had been issuing them since
1924, before which Jean Charles had
been at work alone in the same line.

The *Potato Gatherers* has figures
reminiscent of those in paintings and
drawings of the subject by Millet, and
was accepted as authentic until the
nineteen seventies. It is not without
qualities, but they are not Millet's. It is
composed around two dramatic
silhouettes, a light one of foreground
figures against a dark sky, and a dark
one of background figures against a light
sky. Although Millet used strong
shading, as in 26c, he avoided such
dramatic counterpoints. They are too
melodramatic for the honest images of
rural life at which he aimed, and are
much more reminiscent of Daumier
(see no. 14a), whom Cazot also forged.
The scarecrow-like figures to the left
have also a caricature quality which is
alien to Millet's earnest peasant scenes.
The invisible faces, imprecise anatomical
details and Loch Ness Monster-like
horse are also unlike the swiftly but

26a

26c

precisely drawn features of the figures
in 26c. Note especially the precision of
the articulation of the hands and fingers
in the drawing.

The initials stamped on 26a are also a
clue. They imitate those on authentic
work sold by the family, but are from
none of the authentic stamps.[62]

27a PABLO PICASSO 1881–1973
The Mother's Toilet 1904/5
etching, 23.5 × 17.8

- Leicestershire Museums and Art
 Galleries, Leicester

© DACS 1986

27b ELMYR DE HORY after Picasso
The Mother's Toilet
etching, 25.7 × 17.4 (platemark),

- Private Collection

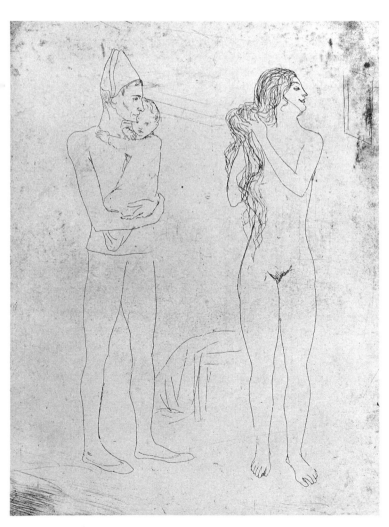

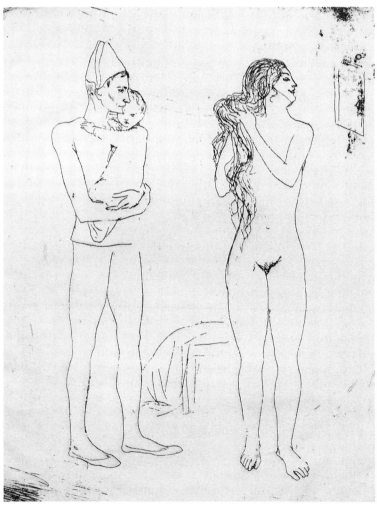

27c ELMYR DE HORY after Picasso
A Nude Man and a Girl in Conversation post 1968
pen and ink on paper,
57.3 × 45.1 (sight)

• Private Collection

Two copies after Picasso, compared with the original of one of them, draw attention to his treatments over decades of the theme of the relationship of the sexes.

These pictures refer to two representations, separated by thirty years, of tense encounters in relationships, in which the figures are reduced to the barest of outlines, yet still express a world of experience. 27a is authentic, an impression from one of a series of plates made by Picasso in 1904 and 1905 and published by the dealer Vollard in 1913, related to a major painting *The family of acrobats*. Some of the scenes in the series suggest an idyllic lifestyle, but not this one in which the woman is pre-occupied with her own preparations, tensely watched by the man holding the restless child.[63]

27b is an impression printed from a plate copied from an authentic impression of 27a. The owner recalls that De Hory told him it was done quite early on in his career, when his work would have been at its best. It follows the original so closely, even in the freest lines and blotches, that is it a formidable achievement if done entirely by hand, and perhaps some photographic process was involved. The lines are just a bit thicker than in the original, and lose some of its wiriness.

The freely drawn lines of 27c, done after de Hory's exposure as a forger in 1968, are much more fluid, indeed a bit too fluid. It is a copy in reverse of a drawing by Picasso of 1933, which used

to belong to Jean Cocteau.[64] This is an intriguing little scene as well, this time in the sculptor's studio, though it perhaps looks as though sculpture may not be the only item on the agenda. The figures also appear separately, somewhat changed, in two prints on related themes in the Vollard Suite,[65] on which Picasso was working at the time. The forger has imitated Picasso's flowing line but without managing to adhere to his sense for anatomy. Compare the wavy line of the woman's lower back and her odd bottom in the copy with the equally free but more anatomically correct line of the authentic drawing, or the figure in the print. The man's bottom in the copy is pretty odd too, and a flourish of his tummy line has given him a funny little raised bulge. Picasso's figures, for all the freedom of their outlines, have a structure and poise upon which the tension of the scene depends. Nevertheless this remains the kind of judgment which is easily made in retrospect. One of De Hory's best drawings, of a related kind but in the manner of Matisse, was amongst the most successful of the many forgeries which he sold to American museums, going to the Fogg Art Gallery at Harvard in 1955.

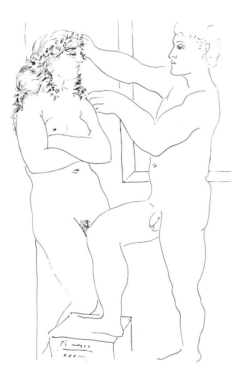

PICASSO *The Sculptor and the Model* formerly collection Jean Cocteau © DACS 1986

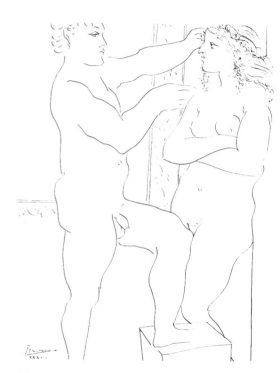

27c

28a LAWRENCE STEPHEN LOWRY
1887–1980
**Group of Figures with a Man
Holding a Baby** 1965
oil on board, 53 × 84 (sight)

• Lent by the Lowry Estate

28b LAWRENCE STEPHEN LOWRY
**Group of Figures with a Man
Holding a Baby**
photomechanical reproduction,
signed by the artist, image size,
45.4 × 71

• City of Salford Art Gallery

An original painting and a limited edition print made from it show the limitations of reproduction.

There is usually no great technical difference between 'signed limited edition prints' like this one, and less expensive unsigned reproductions, or indeed colour illustrations in art books. On this print, as on such illustrations, most of the colours can be seen on very close examination to be made up of tiny separate dots of ink, especially in the dark shadows. The limited edition print will usually be nearer to the original in size and colour, because the plates for it will have been made from a larger format photograph, and because there are more of them, so that it can be printed with a larger number of different coloured inks. For this print, a base tone and one or two colours are added from plates with no 'screen' of dots to them. All this is just taking a bit of extra care over a mechanical process. The 'collectors value' of this kind of reproduction is created by limiting the number of copies (this one is numbered 019) and by getting the artist to sign them. This print was published by Adam Collections Ltd. and printed by Chorley and Pickersgill Ltd.

Lowry was very choosy about which prints he signed, unlike Salvador Dali, according to recent press reports, who is said to have signed blank paper which was then sold to the highest bidder. Great care was taken with this reproduction. All the same, much of the colour has been lost in the process, such as the pink patch above the hat of the man on the left. The yellow in the top right sky is much brighter in the painting, the grey streaks in the sky much darker, and so on. The texture of the paint has resisted reproduction as well. Much trouble was taken to light the picture from the sides for

photography so as to show up the relief of the paint. The brush hairlines in the paint do indeed show up as mainly horizontal lines, dark in the light paint, as in the sky, light in the dark paint, as on the hats protruding over the wall. Normal room lighting of the painting itself does not give these shadows, which confuse the image, whilst still not capturing the detail of the textures. The clothes of the third and fourth adults from the left are painted in two layers of paint, a rather matt layer below, with a shinier layer dragged thinly over the top. In the reproduction, the man's coat shows little clue to the separate layers of brownish grey underpaint, or the broken layer of black on top of it.

29a ANDY WARHOL born 1928
Marilyn 1967
screenprint, 91.5 × 91.5

• Lent by Sheffield City Art Galleries

29b ANDY WARHOL
Marilyn early 1970's
screenprint, 91.5 × 91.5

• Private Collection

A comparison of an authorised printing of a screenprint with a pirate edition.

Andy Warhol's series of ten screenprints of Marilyn Monroe's face in different colour combinations was printed by Aetna Silkscreen Products inc/Du-Art Displays in New York and published there by Factory Editions in 1967. 29a is from this printing and was bought at the Bradford Print Biennial in 1969. 29b is one of a set of eight pirate prints from the original screens made in about 1970 in Germany. It bears on the back the stamp 'Published by Sunday B. Morning'.[66] The pirate prints in this colour combination are close to the colours of the original edition, though the similarity of tone between the background pink and the purple in the original has not been preserved in the later edition.

The pirate print, like the original, is deliberately printed a little out of register. This emphasises accidental qualities of pattern characteristic of the screen-printing process, derived from the regular rows of little holes in the stencil screen, and the rather blotchy effect of the ink forced through them. Almost any way of making a picture involves some characteristic patterns like this, such as the brush marks of oil paint, or the hatched lines of engravings. Even photographs often have a grainy pattern. Many artists have welcomed these patterns using thick paint to show up the marks of the

brush, or carefully preserving the burr of etchings as long as possible. Warhol was only following tradition in extending this idea to screenprint. It is just by playing on the effects discovered in the combination of the image and the patterns characteristic of the medium in which it is drawn, painted or printed, that part of the visual interest of art is created. These are just the effects which forgers and copyists are least able to recapture, and they rarely survive the processes of reproduction either. In this pirate edition however much of the quality of the original is retained. Warhol welcomed the screenprint process precisely because it offered such effects in a technique which could be carried out by assistants, though in practice he seems to have closely supervised authorised printings.

29a
© DACS 1986

REFERENCES

1. FLAMMARION. Camille: *L'Atmosphère, Météorologie Populaire*, 2nd Ed. Paris 1888, p.163.

2. WEBER. Bruno: *Ubi Caelum Terrae Se Coniungit; Ein Altertumlicher Aufrisse des Weltgebaudes von Camille Flammarion*, (Sonderdruck aus dem Gutenberg-Jahrbuch 1973). Thanks to Owen Gingerich for this reference.

3. NEEDHAM. Joseph, and LING. Wang: *Science and Civilisation in China*, Vol 4, part II section 27, plate CCLXV p.542.

4. Such as GREGORY. Richard L.: *Eye and Brain*, London, Weidenfeld and Nicolson, 1966.

5. NOLL. A.M.: *Human or Machine: a subjective comparison of Piet Mondrian's 'Composition with Lines' (1917) and a computer generated picture*. Psychological Record, Vol 16, pp 1-10. Reprinted in HOGG. James, (Ed): *Psychology and the Visual Arts*, London, Penguin, 1961.

6. 'Composition with Lines', oil on canvas 1917. Rijksmuseum Kroller-Muller.

7. KEATING. Tom, NORMAN. Geraldine and Frank: *The Fake's Progress*, London, Hutchinson 1977, p. 229.

8. KEATING. Tom, and NORMAN. Geraldine: *The Tom Keating Catalogue*, London, Hutchinson 1977, p. 78.

9. For both sides of the debate see the Burlington Magazine, vol CXXVIII (No, 997) April 1986.

10. ARNAU. Frank: *Three Thousand Years of Deception*, London, Jonathan Cape 1961 pp. 226-241; & SCHULLER. Sepp: *Forgers, Dealers, Experts*, London, Arthur Barker Ltd., 1960, pp. 71-9.

11. FLEMING. Stuart J.: *Authenticity in Art*, London, Institute of Physics 1975, pp. 43–46.

12. NORMAN. op.cit. note 7, p. 223–225.

13. A number of the techniques are described, along with case studies in which they have been used, in the Technical Bulletins, of which nine have been published since 1977, by the National Gallery, London. For the newer technique of Neutron Activation see FLEMING. op.cit. note 11.

14. Infra-red imaging is not examined in this exhibition, but an interesting case is in LAING. Keith and HIRST. Michael: *The Kingston Lacy Judgment of Solomon*, Burlington Magazine, Vol CXXVIII (No. 997) April 1986.

15. COREMANS. Paul B: *Van Meegeren's Faked Vermeers and De Hoochs, a scientific examination*, London, Cassells, 1949; and WERNESS. Hope B.: *Hans Van Meegeren Fecit*, in DUTTON. Denis, (Ed): *The Forger's Art*, Berkeley, University of California, 1983.

16. FRINTA. Mojmir: *Drawing the Net Closer – the case of I. F. Joni, painter of Antique Pictures*, Pantheon, Heft III, July – August 1982.

17. Fra Filippo Lippi, 'Madonna adoring the Child with St Bernard and the Infant St. John, tempera on panel, Uffizi, Florence.

18. Archives of the Technical Department of the Courtauld Institute.

19. Private communication from Professor Stephen Rees-Jones

20. Sandro Botticelli, 'The St Barnabas Altarpiece' tempera on panel, Uffizi, Florence,

21. Sandro Botticelli, 'The Madonna of the Rosebush', tempera on panel, Uffizi, Florence.

22. Imitator of Melozzo da Forli, 'The Montefeltro Family', tempera on panel, National Gallery, London. inv. no. 3831.

23. VOELKLE. William and WIECK. Roger S. : *The Spanish Forger*, New York, Pierpont Morgan Library, 1978. (in which no. 3 in this exhibition appears as cat. no. p6)

24. Pieter Brueghel the Younger: 'Kermesse with theatre and procession', oil on panel, Fitzwilliam Museum, Cambridge. For many other versions of the whole scene and the detail see MARLIER. George: *Pierre Brueghel le Jeune*, Brussels, Robert Finck, 1961, pp. 294–305.

25. FLEMING. op.cit. note 11, p.31.

26. SLATKES. Leonard J.: *Dirck van Baburen*, Utrecht, Haentjens, Dekker and Gumbert, 1965, p.117.

27. COREMANS. op.cit. note 15.

28. According to Slatkes (see note 26), this was stated at the time of the 1961 British Museum Exhibition 'Forgeries and Deceptive Copies', but no details were included in the little booklet which is all that now remains.

29. Private communication from Professor Stephen Rees-Jones.

30. See note 11.

31. Théodore Géricault, Album of Sketches, folio 38, recto., Art Institute of Chicago. Thanks to Philip Vainker for this reference.

32. Théodore Géricault, 'Cheval que l'on ferre', lithograph, 1823, see DELTEIL. L: Le Peintre Graveur Illustré, Paris 1924, vol XVIII no. 72.

33. RHYNE. Charles, Constable Drawings and Watercolours in the Collection of Mr. and Mrs. Paul Mellon and the Yale Centre for British Art. Part II, re-attributed works. Master Drawings Vol XIX (no. 4), Winter 1981.

34. PARRIS, Leslie and FLEMING-WILLIAMS, Ian; Lionel Constable, London, Tate Gallery 1982 (in which no. 11b in this exhibition appears as cat. 26).

35. Samuel Palmer, 'The Shearers', see LISTER. Raymond: Samuel Palmer and 'The Ancients', Cambridge, Fitzwilliam Museum, 1984, no. 29.

36. NORMAN. op.cit. note 8, 12b in this exhibition is cat. 76, and 12c is cat. 54.

37. See NORMAN. op.cit., Note 7.

38. Thanks to Dr. Marion Spencer for pointing out this pair of paintings.

39. Honoré Daumier, 'Mon Cher Ami', pen and wash, National Gallery of Victoria, Melbourne. Thanks to Philip Vainker for this reference.

40. RIENAECKER. Victor: Paintings and Drawings by Camille Jean-Baptiste Corot, London, Hatton and Truscott Smith Ltd., 1929. (In which cat. 15b in this exhibition appears as cat. 2125, and cat. 15c as cat. 1091.)

41. HUYGHE. René: Simple Histoire de 2414 faux Corots, L'Amour de L'Art, (no. 2) Feb 1936, pp. 73–76.

42. Eugène Boudin, 'Anvers' oil on canvas, private collection, see SCHMIT. Robert: Eugène Boudin, Paris 1973, vol I, no. 662.

43. ROWLEY, Charles: Fifty Years of Work without Wages, London, Hodder and Stoughton, 1916.

44. HUEFFER. Ford Madox: Ford Madox Brown, London, Longmans Green and Co., 1896.

45. FAILLE. Jacob Baart de la: L'Oeuvre de Vincent Van Gogh, Eds. G. Van Oest 1928.

46. FAILLE. Jacob Baart de la: Les Faux Van Gogh, Brussels, Eds. G. Van Oest, 1930.

47. FAILLE. Jacob Baart de la: Vincent Van Gogh, London, William Heinemann, 1939.

48. FAILLE. Jacob Baart de la: L'oeuvre de Vincent Van Gogh, Amsterdam, Meulenhoff International 1970. La Faille's catalogue number for cat. 18 in this exhibition is F418.

49. See note 10.

50. FAILLE. op.cit. note 48., cat. no. F1431.

51. FAILLE. op.cit. note 48., cat. no. F415.

52. THOMSON. Richard: French Nineteenth Century Drawings in the Whitworth Art Gallery, Manchester 1981.

53. Paul Gauguin, 'Les Saules', oil on canvas, Nasjongalleriet, Oslo.

54. Paul Gauguin, 'Le Saule', oil on canvas, private collection, see Lefevre Gallery, London: Important 19th and 20th Century Works of Art, June/July 1983, No. 6, illustrated.

55. Paul Gauguin, 'Landscape at Pont-Aven', oil on canvas, Niarchos Collection.

56. The closest is Raoul Dufy, 'The Marne at Nogent', oil on canvas, 1935, Art Institute of Chicago 1951.315.

57. IRVING. Clifford, Fake: The Story of Elmyr de Hory, London, Heinemann 1970.

58. WHITE. Chris; ALEXANDRE. David & D'OENCH. Ellen: Rembrandt in Eighteenth Century England., Yale Centre for British Art, 1983, no. 125.

59. HARRIS. Tomas, Goya Etchings and Lithographs, Oxford, Bruno Cassirer, 1965.

60. HARRIS. op.cit. note 59.

61. THOMSON. op.cit. note 52.

62. HERBERT. R. L. : Les Faux Millet, Revue de L'Art, (21) 1973.

63. CARMEAN Jnr., E. A.: Picasso, The Saltimbanques, Washington, National Gallery of Art, 1980.

64. Pablo Picasso, 'Le Sculpteur et Le Modèle' ink on paper, see Sotheby sale 29/4/64, lot 100.

65. Pablo Picasso, 'Three Nude Men Standing', etching March 27th, 1933; 'Model and Sculptured Head', etching, April 1st, 1933.

66. FELDMAN. Frayda and SCHELLMANN. Jorg (Ed): *Andy Warhol Prints*, New York, Abbeville Press, 1985, pp. 39 and 113.

LENDERS

The Trustees of the Chatsworth Settlement 6b, 23b
The Lowry Estate 28a
Mrs Frank Norman 12c
Mr and Mrs E. Sniechowski 23a
Tim and Nancy Yates 16b
Private Collections 13a, 20a, 22c, 24b, 25b, 27b, 27c, 29b

AMSTERDAM, Rijksmuseum (on loan from the City of Amsterdam) 5a
BARNARD CASTLE, Bowes Museum 6a, 13c
BEDFORD, Cecil Higgins Art Gallery 12b
BRADFORD, Art Galleries and Museums 7a, 7b
BRISTOL, City of Bristol Museum and Art Gallery 11b
CAMBRIDGE, Syndics of the Fitzwilliam Museum 15a
GLASGOW, The Burrell Collection,
 Glasgow Museum and Art Galleries 9, 14a, 14b
IPSWICH, Museums and Galleries 10a
KENDAL, Abbot Hall Art Gallery 3
LEICESTER, Leicestershire Museums and Art Galleries 27a
LONDON, Courtauld Institute, Department of Technology 1b, 2b, 4
 Courtauld Institute Galleries 5b
 Royal Academy of Arts 11a
 Trustees of the Victoria and Albert Museum 12a
MANCHESTER, City Art Galleries 16a, 17a, 24a, 25a
 Whitworth Art Gallery, University of Manchester
 8a, 8b, 15b, 15c, 19, 21a, 21b, 22a, 22b, 23c, 26a, 26b
NOTTINGHAM, Castle Museum and Art Gallery 10b, 10c, 13b, 17b
OTTERLO, Rijksmuseum Kroller-Muller 18
PARIS, Musée d'art Moderne de la Ville de Paris 20b
PLYMOUTH, City Museum and Art Gallery 26c
SALFORD, City of Salford Art Gallery 28b
SHEFFIELD, City Art Galleries 29a
STALYBRIDGE, Astley Cheetham Art Gallery,
 Tameside Metropolitan Borough Council 1a, 2a

TOUR

Ferens Art Gallery, Hull
9 August to 14 September 1986

Nottingham University Art Gallery
22 September to 25 October

York City Art Gallery
1 November to 7 December

Royal Albert Memorial Museum, Exeter
20 December to 24 January 1987

a full list
of Arts Council publications
including
all exhibition catalogues in print
is available from:
the Publications Office
Arts Council of Great Britain
105 Piccadilly
London W1V 0AU

front cover
left
DE HORY after PICASSO (cat. 27c)

right
PICASSO (cat. 27d)
© DACS 1986

back cover
left
DÜRER (cat. 21a *detail*)
right
RAIMONDI after DÜRER (cat. 21b *detail*)

inside front cover
after VAN BABUREN (cat. 5a *detail*)

page 1
VAN MEEGEREN after VAN BABUREN (cat. 5b *detail*)

page 60
DAUMIER *Mon Cher Confrère (detail)*

inside back cover
after DAUMIER (cat. 14b *detail*)

© David Phillips and
Arts Council of Great Britain 1986

ISBN 0 7287 0505 2

exhibition devised by
David Phillips *organised by*
Michael Harrison with Judith Kimmelman
catalogue designed by
Trilokesh Mukherjee
printed by
Staples Printers St Albans Ltd.

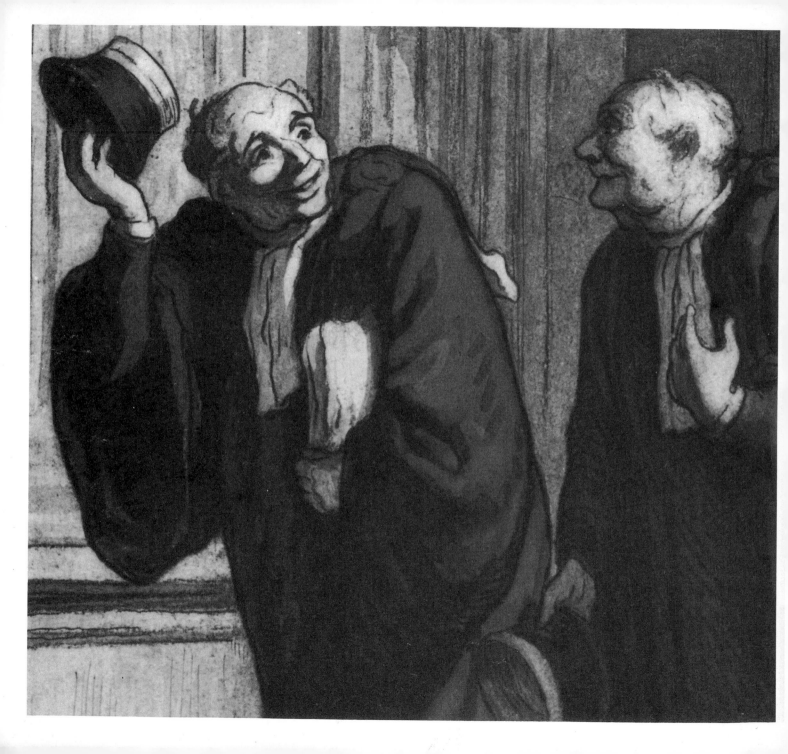